IMAGES
of America

POLISH PITTSBURGH

Stanley States, PhD

ARCADIA
PUBLISHING

Published by Arcadia Publishing
Charleston, South Carolina

Printed in the United States of America

Library of Congress Control Number: 2017952567

For all general information, please contact Arcadia Publishing:
Telephone 843-853-2070
Fax 843-853-0044
E-mail sales@arcadiapublishing.com
For customer service and orders:
Toll-Free 1-888-313-2665

Visit us on the Internet at www.arcadiapublishing.com

To moja piekna mala wnuczka (*my beautiful little granddaughter*) *Lena Catherine States, born on October 7, 2016. While Prince Miescko, the 10th century founder of Poland, is the oldest Pole in this book, she is the youngest.*

CONTENTS

ACKNOWLEDGMENTS

I would like to thank my wife, Kathleen States, for her technical assistance in the preparation of this book.

I would like to thank the following families for providing their photographs and memories for the book: Benkoski-Block, Cyprych, Goliat, Jackson, Kemmerling, Kozlowski, Lane, Lis, Lisowski, Minor, Radovich, Rudiak, Rzaca, Konefal-Shaer, Tuttle, Urbaniak, Warrick, and Wudarczyk.

I also want to thank the Carnegie Library of Pittsburgh and the University of Pittsburgh Library for giving me access to their extensive archives.

INTRODUCTION

Over the past 200 years, several million Poles left their native country and immigrated to the United States. By far the greatest number of Polish immigrants arrived during the last part of the 19th century and the early years of the 20th century. For the immigrants, and their first-generation descendants, life in this new country was difficult, and it took time and a lot of effort to adjust. However, there was a strong motivation to assimilate and Americanize. For many, such as the author's immigrant family, this included shortening a multi-syllabic Polish name, Statkiewicz, to an easier to pronounce, more American sounding name: "States." The motivation to assimilate and Americanize was undoubtedly spurred on by prejudices experienced by Poles, like those experienced by most other immigrant groups that have come, and continue to come, in great numbers to America's shores.

Subsequent generations of descendants from these early immigrants to the United States have shown a great interest in searching for their ethnic identity. This is evidenced by the recent number of books, television shows, and commercially available computer tools (such as Ancestry.com) dedicated to researching one's genealogy. The success of Arcadia Publishing's books describing, in part, the immigration of various ethnic groups to cities across the United States further attests to this popular interest. This book, *Polish Pittsburgh*, is an example of this trend.

It has been said that the four pillars of Polish life among the early generations living in America were home, church, fraternal organizations, and Polish newspapers. This book describes these and more.

The book begins with a brief history of Poland, which helps to explain why so many Poles immigrated to America. Poland has had a long and tumultuous history. Its past is a saga of intermarriages with foreign royalty, conquests, subjugation, partition, re-conquests, and liberation. Poland has been recognized as a European state for over a thousand years, and for much of that time was among the most expansive nations. However, throughout the past millennium, the country has changed political composition many times and has had to deal with extensive, often very aggressive, interventions from its neighbors. All of this turbulence has helped to form a resilient Polish character anchored in common history, geography, language, religion, culture, and traditions. This character traveled with the immigrants who left Poland to come to the United States and has been handed down to many of their Polish American descendants. Poland has traditionally been, and continues to be, one of the most pro-American nations in Europe. This national attitude is strengthened by the large number of Polish citizens who have relatives in the United States. In fact, Polish military units have fought with the Americans under NATO during the wars in Iraq and Afghanistan.

Today, the largest number of Poles living outside of Poland live in the United States. Poles began immigrating to America in small numbers in the early 1600s. Sporadic immigration continued over the next couple centuries. The early immigrants consisted mainly of adventurers, political refugees, and exiles. By far, the greatest immigration to this country, and to Pittsburgh, occurred during the late 1800s and early 1900s. These immigrants were individuals escaping a deteriorating political and economic environment in the Old World, and seeking employment in the industrial

boom of Pittsburgh and other regions of the country. In some cases, Polish immigrants came to America to work and then return to Poland with their "nest egg" to purchase or repurchase farmland. However, most of the immigrants permanently settled in this country. Some Poles, in the late 19th and early 20th centuries, also came to America to escape conscription into the armies of the powers occupying partitioned Poland (such as Russia, Germany, and the Austro-Hungarian Empire). Conscription into these forces could last up to 30 years.

Poles leaving Poland during the mass migrations in the late 1800s and early 1900s left a life of poverty and oppression. However, when immigrating to Pittsburgh, they often found conditions difficult here as well. They worked long hours for low wages under dangerous conditions. Living conditions here were also poor. Immigrant life in Pittsburgh was typical of most northern industrial cities in the United States.

Like other immigrant groups before and after them, Poles experienced their share of ethnic prejudice in America. Part of this was associated with their non-Protestant, Roman Catholic religion. Some of the prejudice also resulted from worries, on the part of groups already settled in America, about being overrun with Eastern European immigrants. The term "Polack" was a commonly used ethnic slur.

While the Polish neighborhoods in Pittsburgh received few newcomers after 1930, the neighborhood Catholic churches and schools, fraternal organizations, businesses, newspapers, and other organizations continued to flourish. They provided services, comfort, and leisure activities to several generations of residents still residing in the neighborhoods. By the end of World War II, many of Pittsburgh's Polish Americans had gradually assimilated into the larger American society and were moving out of the old neighborhoods.

In recent years, some of the traditionally Polish neighborhoods in Pittsburgh have experienced a resurgence. Young people and new businesses are moving into the old ethnic neighborhoods of the Strip District, Lawrenceville, Polish Hill, and the South Side. While the ethnic character of these neighborhoods is not as apparent as in earlier decades, some, such as Polish Hill, are still very proud of their heritage. The ethnic parishes remain an important part of the Polish American culture today. Although the majority of Pittsburghers of Polish lineage now live in the suburbs removed from the ethnic neighborhoods, a surprising number are drawn back to the old parishes for funerals, weddings, and holiday celebrations.

"Polonia" is the term used to describe the Polish community in the United States. In settling Pittsburgh, ethnic groups, including the Poles, typically first built fraternal societies and then churches. The fraternal organizations were instrumental in the building of new churches and parochial schools, as well as in financing existing parishes. Each fraternal organization helped to preserve ethnic unity and maintain Polish culture for people who had left their native country and for their children. Over the years, the fraternal societies also devoted large sums of money to humanitarian, social, educational, religious, and cultural activities. The efforts of fraternal organizations to maintain Polish culture were not simply seen as important for group preservation in America. They were also part of the campaign to revive the Polish state in Europe.

Originally formed as beneficial societies, by the 1930s, the fraternal organizations became more focused on social brotherhood and political actions. The members continued to pay for and receive sickness and death benefits. However, other functions like education and recreation helped them to provide a continuing role for first and second generation Polish Americans. Some of the organizations, like the South Side Polish Falcons, maintained gymnasiums and small libraries in their buildings. Nearly all had social gathering places, which after Prohibition included drinking facilities.

Unfortunately, with the passage of years, membership in most of the fraternal societies has greatly declined as older members with closer ties to the Old Country have passed on.

As in the population of Poland itself, the majority of Polish immigrants to America were Roman Catholic. The number of Polish parishes in the United States grew steadily from 512 in 1900 to 800 in the 1930s. The priority that the immigrant Poles gave to building impressive churches, despite their lack of money, underscores the importance that they placed on churches

in their communities. The building of a church in a neighborhood was an indication of a group's intention to settle there.

The eight Polish Roman Catholic churches that were built in Pittsburgh, as well as their schools, have shown a decline in membership since World War II. As a result of extensive consolidation of parish schools in the Diocese of Pittsburgh, none of these Polish parishes currently have school programs. Since the 1990s, a number of the Polish Roman Catholic churches and Polish National Catholic churches in Pittsburgh and the surrounding area have closed or merged with other parishes. For example, St. Stanislaus Kostka Parish in the Strip District merged with Saint Patrick Parish and Saint Elizabeth of Hungary Parish in 1993 to form Saint Patrick–St. Stanislaus Kostka Parish.

The Polish American community had a number of Polish-language newspapers and other publications dedicated to immigrant Poles. Many of these were published by the fraternal societies. Chapter six in this book describes the most important ones that served Pittsburgh Poles.

Although the nation of Poland totally disappeared from the map of Europe during the "Great Partitions" of 1795 to 1918, Poles in the Old Country and America never gave up hope for the rebirth of a Republic of Poland. Many of the early immigrants to the United States, such as Thaddeus Kosciusko, came here with the intent of returning to Europe to fight for Polish independence. Some significant efforts toward this goal were taken in the United States, especially in Pittsburgh, during the 20th century. These are briefly described in chapter seven.

Chapter eight describes some of the efforts a couple of Pittsburgh Polish families have made to maintain their ties with family left behind in the Old Country over the past 100 years.

Over the thousand years since Poland first became a nation, a number of customs and traditions, many of them associated with religious holidays, have been established. These are an important part of Polish culture. They have traveled to the United States with the waves of Polish immigrants over the past several hundred years, and continue to be observed by Pittsburgh Polish Americans. Chapter nine describes some of the more important of these customs and traditions.

And finally, in chapter ten, "Pittsburgh Polonia Today," an account is given of the businesses, organizations, and celebrations that are keeping the Polish American culture alive in Pittsburgh.

One

A BRIEF HISTORY
OF POLAND

To understand the mass migration from Poland to the United States, and the cultural identity of the immigrants and their descendants, it is helpful to briefly review the history of the Polish nation.

The Slavs who formed the country of Poland migrated to that area of Europe in the 5th century AD. The Polish people descended from Slavic tribes that lived in the forests along the Vistula River. It is believed that one tribe was called Polanie, meaning "people who live in the fields." The written history of the nation dates to 840–900 AD, with the formation of the Piast dynasty. Over the centuries, the Poles gradually developed a separate identity from the other Slavic groups that gave rise to Russians, Czechs, Slovaks, Serbs, Croats, and kindred nationalities. Poland became a Christian kingdom in 966 when Prince Mieszko I married a Christian Bohemian (Moravian) princess, Dubravka, and was baptized a Roman Catholic.

Boleslaw I (992–1025), who succeeded his father Mieszko, consolidated Polish lands and conquered territories outside of the present-day borders of Poland. In 1138, the Polish kingdom was divided into six duchies when Boleslaw III divided his lands among his four sons. This division of Poland led to internal wars, which ultimately weakened the nation.

In the 14th century, the Polish Jagiello dynasty (1386–1572) followed the Piast dynasty. The Polish lands were reunited under one crown, and Poland emerged as a powerful kingdom. In 1386, Poland was formally linked by dynastic ties to the Grand Duchy of Lithuania. The United Polish–Lithuanian Kingdom became the largest empire in Eastern Europe.

Over the years, especially under the Jagiello dynasty, Poland demonstrated a tolerance of ethnic and religious groups that was unheard of in other parts of Europe. Poland encouraged immigration by Jews, Muslim Tartars, and Protestants, and allowed them to practice their religions with fewer restrictions than in other countries. Poland truly was a multiethnic, multi-religious society. During his reign from 1330 to 1370, King Casimir the Great consolidated the nation and raised the Polish crown to a first-class power among the European nations.

Poland has had to deal with numerous external threats throughout its history. This included foreign invasions by the Tartars (Mongols), who laid waste to the city of Krakow in 1241. Other invading forces included the Teutonic Knights in 1308, Ukraine and Russia in 1648, and the Swedes in 1655. Foreign intervention continued in later centuries, of course.

The period of the 14th to 16th centuries is referred to as the golden age of Poland. Human rights, science, literature, and the arts flourished.

In 1572, the reigning Jagiello dynasty died out. The Poles replaced the dynasty with a political experiment: the Commonwealth. Under the Commonwealth, the influence of the king gradually weakened while the Polish nobility became more powerful.

In 1683, King John Sobieski of Poland led a European coalition in defeating the Ottoman Turks at the siege of Vienna, saving Europe from Muslim invasion and rule. King John Sobieski's reign (1674–1696) marked the end of Poland's golden era of stability and prosperity.

The period from the mid-17th to the mid-18th century is commonly viewed as the time of Poland's great political and economic decline. Poland was plagued with internal problems of disunity and ceased to function as an effective nation. These political changes, along with a lack of natural protective geographical barriers like oceans and mountains between Poland and its powerful neighbors, were a recipe for foreign intervention. Sweden, Russia, Turkey, the Crimean Tartars, and Ukrainian Cossacks all attacked Poland.

In 1791, Poland adopted a new constitution written in the spirit of the Constitution of the United States. However, at this point Poland was very weak. Taking advantage of the lack of a strong Polish central government, in the following year Catherine of Russia invaded Poland and partitioned it among Poland's three largest neighbors (Prussia, Austria, and Russia) making Poland a nation without a state. After 829 years of independence (966–1795), Poland was wiped off the political map of Europe for the next 123 years (1795–1918).

During the time of the partitions, a series of unsuccessful uprisings were conducted in an attempt to restore the Polish nation. During this period, thousands of Poles, especially the leaders of the insurrections, were executed, imprisoned, or exiled to Siberia. Many left for foreign shores including the United States.

In August 1914, World War I found the three partitioning powers in Poland at war with each other. Germany and the Austro-Hungarian Empire were fighting Russia. The armies of all three powers descended upon Poland, and the area was a hotbed of armed conflict. During the war, two million Poles fought with armies of the three occupying powers, and 450,000 died. On November 12, 1918, the day after the German surrender, the Poles took charge of their country and expelled the foreign troops. An independent Polish state officially emerged from the Treaty of Versailles, and Poland regained its independence as the Second Polish Republic.

Unfortunately, the peace following World War I in Poland was temporary. The Russo-Poland War was fought from 1919 to 1921. The war resulted from conflicting claims by both Russia and Poland to territory based on natural and ethnic boundaries. For Poland, the alternatives were to survive as an independent nation or become part of Soviet Russia under Lenin and Trotsky. Poland defeated the Red Army at the Battle of Warsaw. This is thought to have halted the early penetration of communism into Europe.

The newly regained Polish independence was short lived. On September 1, 1939, Nazi Germany invaded Poland from the west, marking the beginning of World War II. Sixteen days later, the Soviet Union invaded from the east. Of all the countries involved in World War II, Poland lost the highest percentage of its citizens, about 20 percent—over six million people. Half of the fatalities were Polish Jews, and more than 90 percent of the overall deaths were nonmilitary in nature. Polish population numbers did not recover until the 1970s.

With the defeat of the Nazis in 1945, Poland was ceded to the Soviet sphere of influence, as agreed upon by the great powers during their meeting in February 1945 at Yalta. Poland became a satellite state of the Soviet Union and endured 50 years of brutal communist oppression. However, during the communist regime, the spirit of Polish national identity again remained intact.

Labor turmoil in 1980 led to the formation of the independent trade union Solidarnosc (Solidarity), which became a significant political force. The Solidarity movement, accompanied by massive nationwide strikes, heralded the collapse of communist regimes in Poland and across Europe. In September 1989, Poland recovered its own state and established itself as a democracy. Industry was privatized and the country transformed its socialist-style planned economy into a primarily market based economy. Poland joined NATO in 1999 and the European Union in 2004. Poland is now the sixth largest economy in the European Union and has emerged as a country of 38 million people with a growing economy.

EUROPE. The borders of Poland have changed many times over the past 1,000 years. The name Poland, which is derived from the Polish name Polska, may have as its root the Polish word *pole*, which means "field." (Stanley States.)

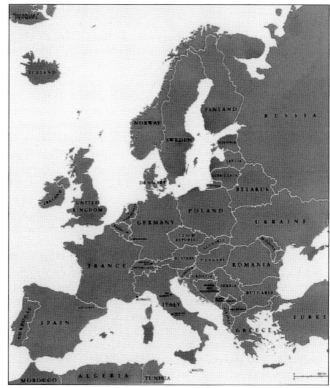

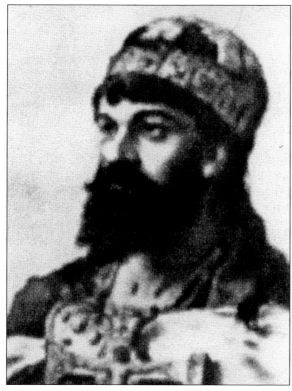

PRINCE MIESZKO I. When Prince Miesko I was baptized in 966, he brought the Polish nation into the developing Western European world. Mieszko's decision to accept Christianity was more political than spiritual. (Stanley States.)

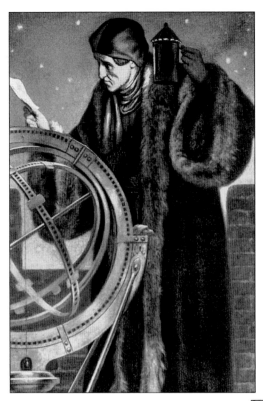

COPERNICUS. The astronomer Nicholas Copernicus (1473–1543), a Polish priest, was the first to publish the revolutionary idea that the earth and other planets orbit around the sun and the earth rotates on its axis every 24 hours. (Stanley States.)

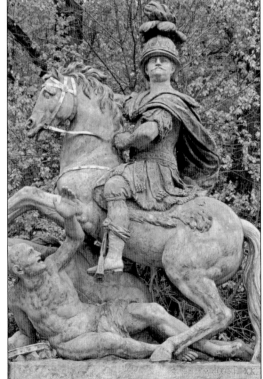

JOHN SOBIESKI. King John III Sobieski of Poland saved Europe from Islam in 1683 when he led a multinational army that defeated Turkish troops laying siege on Vienna. This is the Sobieski monument in Lazienski Park in Warsaw. (Stanley States.)

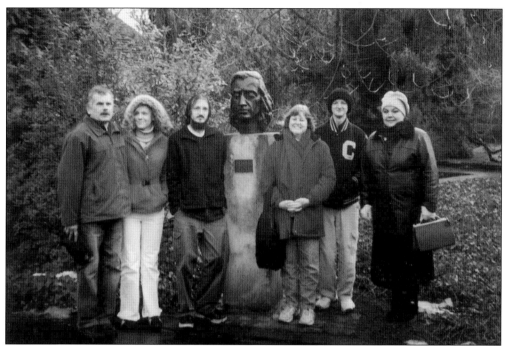

CHOPIN. The iconic Polish composer Fryderyk (or Frédéric François) Chopin (1809–1849) was credited by the French composer Camille Saint-Saens with having voiced in music the very heart and soul of the Polish people. This is the Polish American States family and their cousins, the Polish Domachowska family, visiting the childhood home of Chopin in Zelazowa Wola, 50 kilometers west of Warsaw, in 2005. (Stanley States.)

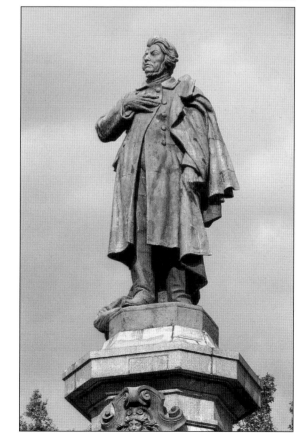

ADAM MICKIEWICZ. The poet Adam Mickiewicz (1798–1855) wrote the nostalgic novel in verse *Pan Tadeusz* (*Master Thaddeus*), which is considered to be the Polish national epic. (Stanley States.)

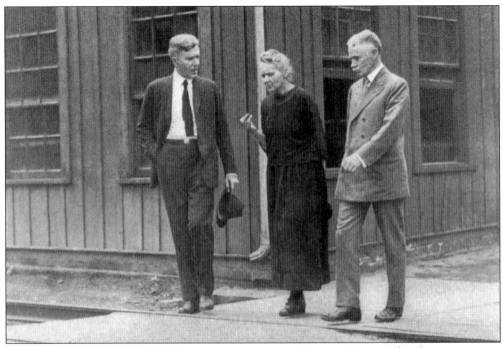

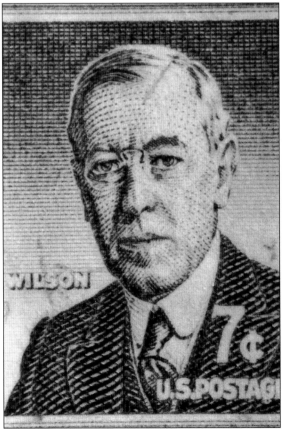

MADAME CURIE. The chemist and physicist Maria Sklodowska Curie (1867–1934), the discoverer of the chemical elements radium and polonium, was the recipient of two Nobel prizes. This photograph shows Madame Curie in 1921 when she visited the Standard Chemical Company Mill in Canonsburg, Pennsylvania, just south of Pittsburgh. Accompanying Curie were two officials of the company, Louis Voight (left) and James Gray. (Carnegie Library of Pittsburgh)

WOODROW WILSON. After being partitioned and disappearing from the political map of Europe for 123 years, an independent Polish state again reemerged from the Treaty of Versailles at the end of World War I. Much of the credit for this outcome goes to Pres. Woodrow Wilson, who had made clear his support for an independent Poland in his "14 Points." Polish Americans and Poles in Poland were very grateful for the American president's efforts. (Stanley States.)

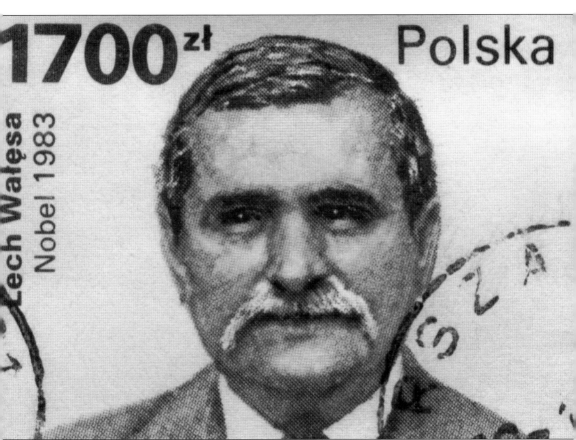

LECH WALESA. The electrician turned political leader Lech Walesa (born in 1943) was the head of Solidarity, the labor movement that after a decade-long struggle toppled the communist government in Poland in 1989. Walesa and his wife visited and spoke in Pittsburgh after he had served as the first elected president of the free nation of Poland from 1990 to 1995. Walesa was named *Time* magazine's Person of the Year in 1981 and received the Nobel Peace Prize in 1983. (Stanley States.)

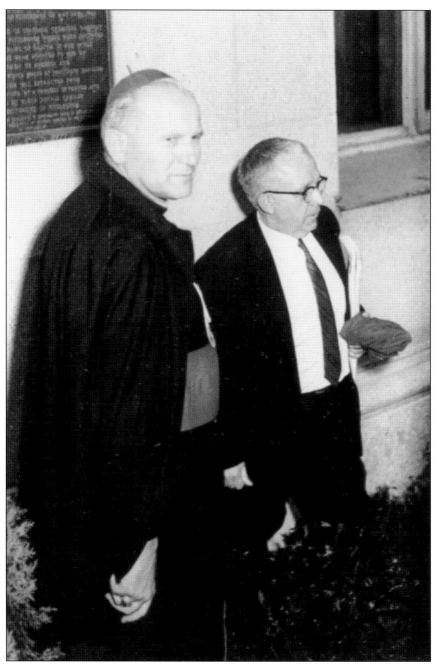

JOHN PAUL II. Pope John Paul II (Karol Josef Vojtyla) was the first Slavic pope and the first non-Italian pope elected since 1522. Along with Lech Walesa, Pope John Paul II (1920–2005) is credited with hastening the downfall of communism in Poland and throughout Europe. He is shown in this photograph dedicating a plaque to Madame Curie at the University of Pittsburgh in 1969 while he was still a cardinal. The pope is accompanied by Pittsburgh Polish historian Joseph Borkowski. Borkowski published much original research on the Polish people in Pittsburgh, and this author has relied on his work extensively as reference material for this book. (Carnegie Library of Pittsburgh.)

Two

MIGRATION FROM POLAND TO PITTSBURGH

The first known Polish immigrants to America were craftsmen who arrived in Captain John Smith's Jamestown Colony in 1607. Another early group of Polish immigrants arrived in New Amsterdam (New York City) in the mid-1600s. Poles also settled in the Delaware Valley as early as 1650, in the days of that colony's founder, William Penn. During the colonial period, most Polish immigrants were men of industry who arrived sporadically and in small groups. Because Poles were among the smallest ethnic groups living in Pennsylvania at this time, they were too small in number to form separate communities and were absorbed by larger groups. The Poles arriving in America before the American Revolution immigrated mainly for ideological and romantic reasons.

During the Revolutionary War, 23 Poles from Pennsylvania served in Washington's army. During this period, most Polish immigrants were political exiles and included soldiers, noblemen, and intellectuals.

After the American Revolution, and before the mass migrations of the late 1800s and early 1900s, most Poles immigrating to the United States were small groups of political refugees or exiles. Their immigration was prompted by intense nationalistic and political beliefs. The occupation of Poland and the harsh consequences following the failed revolts against the partitioning powers were major factors in the migration of Poles to the United States and other countries. Many of these immigrants were Polish leaders and aristocrats. In some instances, Poles who had already migrated to the United States eventually returned to Poland to aid in subsequent revolts against the occupying powers. Poles immigrating to America during this period dispersed throughout the United States and assimilated rapidly, making it difficult for them to sustain organized Polish life and customs. Thaddeus Adamski was the first Pole known to own land in Southwestern Pennsylvania. He purchased 200 acres near the present city of Clairton in 1789.

After 1870, and continuing to 1914, a much larger wave of Polish immigrants, the peasants, arrived in America. These were *za chlebem* (economic, or "for bread") immigrants. The population of Poland had risen steadily, and economic opportunities in the Old Country were vanishing. Villages were overpopulated, and there was an excess labor force. Wealthy estate owners were purchasing much of the land. These immigrants were typically impoverished rural people with only rudimentary education who wanted to improve their economic lot. In some cases, Polish immigrants would come to America for work and then return home with their savings to purchase or try to repurchase farmland. Unskilled labor was in demand in the rapidly expanding American industrial economy. Many found work in the coal mines and steel mills of Southwestern Pennsylvania.

The mass immigration ended at the beginning of World War I because the war so drastically affected Poland. It has been estimated that as many as two million Polish immigrants arrived in this country between 1870 and 1914, with the one-year peak being 174,365 in 1912.

During the mass immigration in the late 1800s and early 1900s, Poles came to Pittsburgh in successive waves: first from provinces under the control of Germany, then Russia, and finally the Austro-Hungarian Empire. The average year of immigration to Pittsburgh by Poles from the various sectors of occupied Poland was 1886 for German Poles, 1889 for Russian Poles, and 1891 for Austro-Hungarian Poles.

Migration from the German controlled portion of divided Poland began when Prussia assumed leadership of a united Germany during the Franco-Prussian War of 1870 and formed a large German empire. Otto Von Bismarck initiated a "Kulturkampf" campaign and began to Germanize the Poles in the German held sector of Poland. This policy involved a mandate against the use of the Polish language, the purchase by Germans of the estates of Polish nobility, and mass expulsion of thousands of Poles.

Immigration from the Russian controlled portion of Poland was encouraged by efforts to Russianize the population, lack of economic opportunities, and conscription of young men into the Czar's Imperial Army, which often involved long years of service in Asia.

Galicia, the Polish part of the Austro-Hungarian Empire, was the most impoverished of the Polish lands. Heavy taxation and government neglect motivated Poles from this region to escape to America. Most of the Poles who came to Pittsburgh were Galicians. Many from the Carpathian Regions (Gorale) settled near the steel mills and coal mines of Mount Pleasant, Uniontown, and the Johnstown area.

Seeking employment in Pittsburgh industry, the Polish immigrants settled in close proximity to the factories, which were located along the rivers. The number of Pittsburgh residents originating from Poland increased 39 percent between 1900 and 1920.

From 1921 to 1975, Polish immigration to the United States was very low. The Immigration Act of 1924 placed severe limits on immigration from eastern and southern European countries.

A small wave of Polish immigration to the United States occurred after World War II. The Displaced Persons Act of 1948 permitted refugees from war-torn Europe to migrate to the United States. Approximately 154,000 Polish citizens came to America between 1948 and 1952, with about one third of these being Polish Jews. Approximately 24,000 Polish refugees settled in Pennsylvania. The refugees who came to Pittsburgh established their own organization, the Association of Polish Combatants for World War II.

Estimates of the total number of Poles who have immigrated to the United States over the centuries exceed two million. The precise number is difficult to determine because many of the immigrants were classified by the US Immigration and Naturalization Service as Russian, German, and Austrian due to the partition of Poland from 1795 to 1918. An exact count is also complicated by the fact that Poland's borders have changed so many times over the years. According to the 2010 US Census, 9.5 million Americans claim Polish ancestry. While the largest number of Polish Americans live in the Chicago area, Pittsburgh and Western Pennsylvania are still an important center of American Polonia.

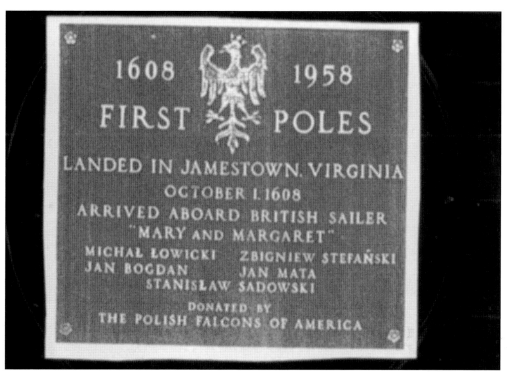

JAMESTOWN PLAQUE. This plaque in Jamestown, Virginia, honors the Poles who helped settle the Jamestown Colony. (Carnegie Library of Pittsburgh.)

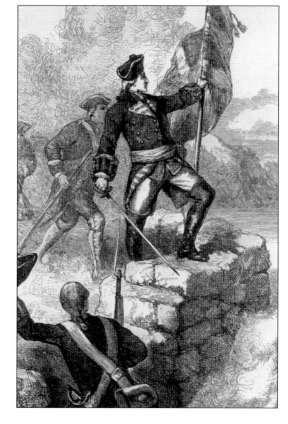

FORT DUQUESNE. Christian Post, a missionary born in Chojnice Poland in 1710, worked among the Indians at Fort Duquesne in the center of what would become Pittsburgh. He traveled to Fort Duquesne at the behest of Gen. John Forbes. Father Post's efforts among the Indians helped win their loyalty away from the French and consequently helped motivate the French to abandon the post to the approaching British forces led by General Forbes. (Stanley States.)

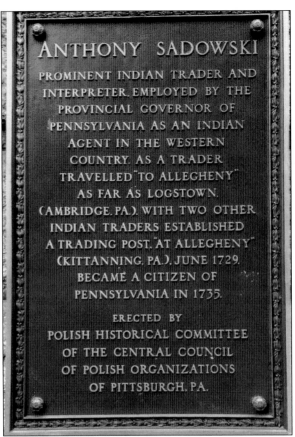

ANTHONY SADOWSKI PLAQUE. Anthony Sadowski (1669–1736) was a trader, explorer, and translator of Native American languages. It is claimed that he was the first Pole in Western Pennsylvania. This plaque was erected in his memory on a wall of the county courthouse in Downtown Pittsburgh. (Stanley States.)

PITTSBURGH AROUND 1838. A Pittsburgh newspaper advertisement in 1938 read, "G. Tochman (late major in the Polish army), and J.T. Herbst (late captain in the same service) will make translations from and into the French, Spanish, German, and Polish languages and will assist persons desirous of corresponding in any of them having secured a large and commodious house in Smithfield Street three doors from the corner of Fourth Street." (Stanley States.)

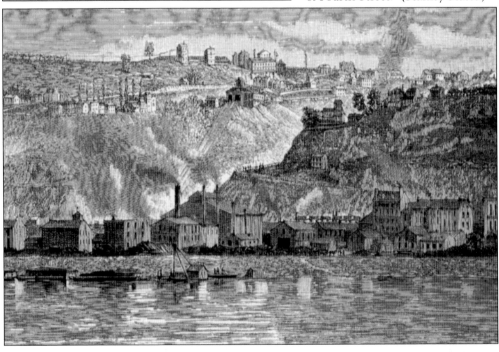

Thaddeus Kosciusko. Tadeusz Kosciuszko, a leader in the fight to regain Polish independence, was forced to leave Poland following the first partition of the country in 1772. Kosciusko joined George Washington's army in America's struggle for independence from England. An engineer, he rose to the rank of brigadier general. He designed the fortifications needed to protect Philadelphia and the military facilities at West Point. He is credited with masterminding the defeat of the British at Saratoga. At the close of the American Revolutionary War, Kosciusko returned to Poland and led an unsuccessful insurrection in 1794 against Russian control of his native country. He could not tolerate injustice: he lamented the fate of peasants in the Old Country and was a fierce critic of slavery in the New World. Thomas Jefferson called Kosciuszko "as pure a son of liberty as I have ever known." (Stanley States.)

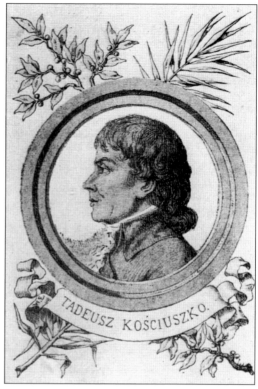

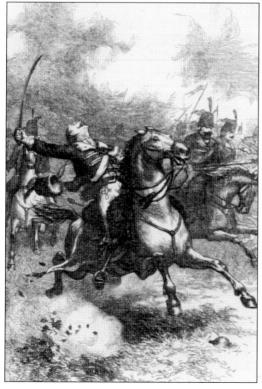

Casimir Pulaski. Casimir Pulaski, like Kosciusko, was forced to leave Poland because of his activities as a Polish freedom fighter. A Polish nobleman with a reputation as a cavalryman, he also joined Washington's army and attained the rank of brigadier general. Pulaski spent tens of thousands of dollars of his own money on the American cause. He was mortally wounded leading a cavalry charge in the defense of Savannah, Georgia, in 1779. (Stanley States.)

23

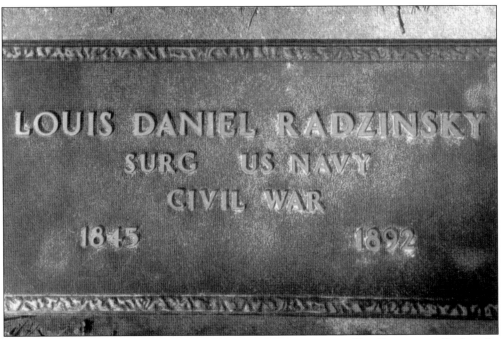

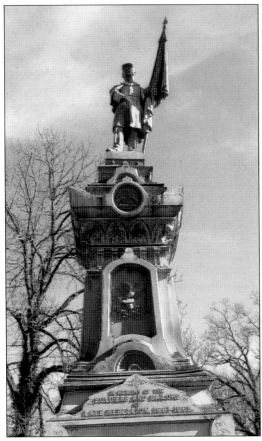

TOMBSTONE OF DR. RADZYNSKI. Radzynski was an American Civil War veteran of Polish extraction from the Pittsburgh area. Dr. Radzynski, born in Geneva, Switzerland, in 1835, was educated in Europe and in this country. He enlisted as a surgeon's mate with New York's 36th Infantry Regiment on July 4, 1861. He later became a surgeon with the 54th Massachusetts Infantry Regiment and then with the 104th US Colored Infantry Regiment. After the war, Dr. Radzynski settled in McKeesport, a small town just outside of Pittsburgh, and is buried in the soldiers' plot of the town cemetery. (Stanley States.)

CIVIL WAR MEMORIAL. This memorial is located in the McKeesport cemetery soldiers' plot where Maj. Radzynski is buried. Approximately 4,000 Polish immigrants served with the Northern army and 1,000 with the Confederacy. Approximately 500 Union Polish soldiers and 100 Confederate Polish soldiers died during the conflict. Three Polish American privates were awarded the Congressional Medal of Honor for bravery in action: Joseph Sowa, Philip Szlachta, and David Urbanski. (Stanley States.)

PLAQUE HONORING POLES WHO FOUGHT IN THE AMERICAN CIVIL WAR. This plaque was erected on a wall of the Pittsburgh City-County Building in Downtown Pittsburgh to honor the Poles who served in Pennsylvania regiments during the Civil War. (Stanley States.)

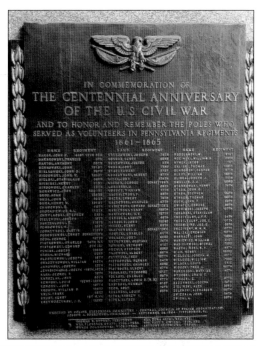

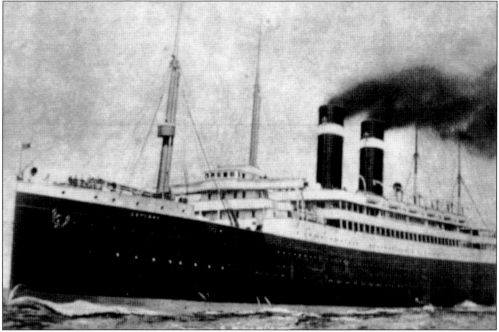

SS *LAPLAND* PASSENGER SHIP. The *Lapland* was typical of the passenger steam ships that transported Polish immigrants from Europe to the United States in the late 1800s and early 1900s. In the autumn of 1912, then-21-year-old Theresa Piwowar left Witowice Dolne, Poland, never to return again. Her brother John, who had previously immigrated to the New Country, had written her and urged her to follow him to America. His letter hinted at available husbands in a flourishing industrial city. Theresa traveled from her home to Antwerp, Belgium, boarded the *Lapland*, and arrived at Ellis Island on November 18. (Lane family.)

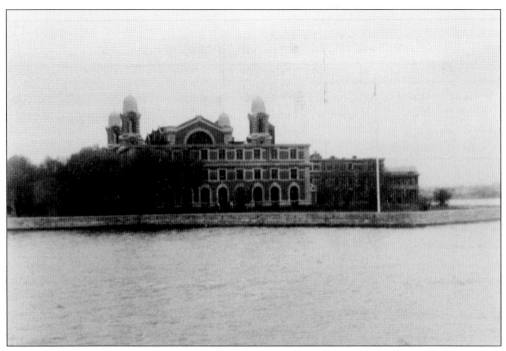

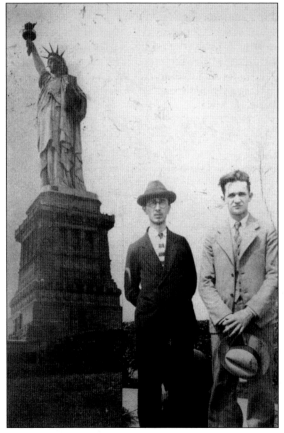

ELLIS ISLAND. The first stop for most Polish immigrants coming to the United States between 1892 and 1954 was Ellis Island in New York Harbor. (Stanley States.)

STANLEY AND JOSEPH STATKIEWICZ AT STATUE OF LIBERTY. Stanley Statkiewicz immigrated to the United States from Poland with his parents in 1911 as a young child. He always told the story that one of his earliest memories was his father holding him up to view the Statue of Liberty as their ship entered New York Harbor. He recalled the excitement of all his fellow passengers on seeing the statue for the first time. In this photograph, Stanley (right) and his brother Joe revisit the statue 17 years later in 1928. (Stanley States.)

SHIP MANIFEST FOR JAN RUDIAK. This is a ship's manifest showing the voyage of Jan Rudiak to America in 1902. Rudiak signed a contract with an agent enlisting coal miners to come to the United States from his small town of Ropienka in Galicia (the region of southeastern Poland that was then under the control of the Austro-Hungarian Empire). He sailed from Bremen, Germany, to New York City and initially worked as a coal miner in Luzerne County (Northeast Pennsylvania) and then relocated to Lyndora, Pennsylvania (near Butler, north of Pittsburgh). Rudiak later worked in the railroad yards. (Rudiak family.)

NATURALIZATION PAPERS FOR JAN BAKOWSKI. The naturalization papers for Jan Bakowski, a Polish immigrant who became an American citizen in 1944, are pictured here. As indicated on the form, he was living at 1814 Harcum Way on the South Side when he was naturalized. (Rudiak family.)

CITIZENSHIP TEST STUDY MATERIALS. Study materials were prepared by the American Citizenship League of Pittsburgh and provided to immigrants preparing for the test to become US citizens. (Lis family.)

THE AMERICAN CITIZENSHIP LEAGUE OF PITTSBURGH
2nd Fl., Chamber of Commerce Building
Seventh Avenue & Smithfield Street

Questions and Answers

GENERAL QUESTIONS

1. What is the name of this country? The United States of America.
2. Why is it called the United States? Because it is made up of many States.
3. How many states are there in the United States? Forty-eight. (48)
4. How many states were in our country when it was first formed? Thirteen (13.)
5. How many stripes in our flag? Thirteen (13). - one for each original state.
6. What is the meaning of the colors in our flag? Red for courage, white for purity and blue for loyalty.
7. How many stars are in the flag? Forty-eight, one for each state in the United States.
8. How are the States united? Under one government.

GENERAL HISTORY QUESTIONS

9. Who discovered America? Christopher Columbus, on the 12th day of October 1492
10. Who was the first President of the United States? George Washington.
11. What are the territories of the United States? Alaska, Hawaii, Puerto Rico, Virgin Islands.
12. What is the Monroe Doctrine? In 1823, President Monroe announced that the United States would protect all American countries from European interference.
13. When was the Armistice signed for the World War? November 11, 1918.
14. Why do we celebrate the Fourth of July? It is the day we celebrate our independence.

QUESTIONS ON FEDERAL GOVERNMENT

15. What kind of government does the United States have? It is a Republic.
16. What are the three branches of government?
 1. Legislative branch makes the laws.
 2. Executive branch sees that the laws are enforced.
 3. Judicial branch interprets the laws.
17. Who is the President of the United States? Franklin D. Roosevelt (Democrat) A President must be native born, 35 years old and have lived in the United States 14 years.
18. Who is the Vice President? Hon. John N. Garner. The Vice President is next to the President and takes his place if the President dies.
19. What is the President's work? To execute the laws of the nation.
20. Who makes the laws for the Nation? Congress. Congress is a group of men selected to make these laws. They meet in Washington, D. C., which is the capitol city of the United States.
21. What are the two divisions of Congress? The Senate and the House of Representatives.
22. How many Senators does each State send to Congress? Two (2)
23. How many Representatives does each state send to Congress? The number of Representatives each State sends is governed by its population. Pennsylvania has thirty-four (34) Representatives.
24. What is the President's Cabinet? A group of men who assist the President in his work, each of whom is at the head of a government department. These men are appointed by the President.

IMMIGRANTS IN FRONT OF DOORWAY. Polish immigrants are pictured in Pittsburgh in the early 1900s. Immigrants lived in cramped boardinghouses or small, drab apartments where many people shared the same kitchen, bedroom, and bathroom. (Carnegie Library of Pittsburgh.)

POLISH IMMIGRANTS ON STAIRCASE. A Polish Row stairway is seen here in the early 1900s. Privacy was an unknown luxury in immigrant Pittsburgh. Polish immigrants influenced the settlement patterns of other Poles through kin migration. Letters of recent immigrants to family and friends still in Poland described the job opportunities and better living conditions available in America. As Polish immigrants joined family and friends in the United States, a pattern of chain migration developed. (Carnegie Library of Pittsburgh.)

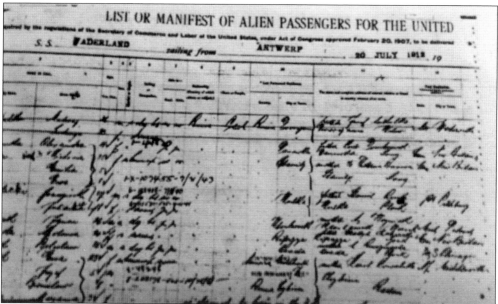

SHIP MANIFEST FOR JULIANNE RUCKA. Julianna Rucka was listed as age 18 on the ship manifest, but her family believes that she was really younger than that. She traveled with her brother Frank Rucki aboard the passenger ship *Vaderland*. Julia and her brother embarked from Antwerp, Belgium, and arrived in New York on July 31, 1913. Although she was born in Wulka, Poland (a small town near Warsaw), her place of birth on the passenger list indicates Russia. This is because Warsaw, at that time, was located in the Russian controlled section of partitioned Poland. The brother and sister initially settled on Polish Hill in Pittsburgh. (Kemmerling family.)

Świadectwo urodzenia i chrztu św.

wydane na podstawie metrykalnych ksiąg kościelnych z roku *1897* Nr aktu *73*

Zaświadczam, że *Julianna Rucka*

córki *Stanisława* i *Aniela z Kempińskich*

małżonków *Ruckich* zamieszkałych w *Wulce*

urodzony (a) dnia *19 maja* tysiąc dziewięćset *dziewięćdziesiątego siódmego 1897* r.

w *Wulce* ochrzczony (a) został (a) dnia *20 maja 1897* r.

osiemset tysiąc dziewięćset *dziewięćdziesiątego siódmego 1897* r.

Adnotacje: (o zgonie, małżeństwie).

Proboszcz

pod Zarz. Państw. w Rypinie – 4.47. 5.000 D

BIRTH CERTIFICATE FOR JULIANNA RUCKA. This is a copy of Julianna Rucka's birth/baptism certificate, obtained by her family in 1947 from the Roman Catholic Diocese of Plock, Poland. This document indicates that Julianna was born on May 19, 1897, in Wulka, Poland, and was baptized the next day. Her father was Stanislaw (Stanley) Rucki, and her mother was Aniela (Angeline) Kempinska Rucka. The "i" at the end of her father's last name (Rucki) denotes the masculine gender, while the "a" at the end of her mother's last name (Rucka) denotes the feminine gender. Julianna Rucka's family in Poland lived on a farm and raised horses. She had a scar on the bridge of her nose throughout her life from when a horse had kicked her as a child. (Kemmerling family.)

KAMINSKI FAMILY HOME. This is a sketch of the Kaminski family home on Fisk Street in Lawrenceville, where Julianna Rucka Kaminski raised her family. She shopped on Butler Street and bought live chickens at the open market. She would bring the chickens home and kill and pluck them. She had a reputation for being an excellent cook. She baked bread and cookies and made her own pierogis and a variety of soups, including chicken soup from the chickens that she butchered herself. She used the feathers from the chickens to make down comforters. (Kemmerling family.)

Three

IMMIGRANT LIFE IN POLISH PITTSBURGH

Pittsburgh's topography of hills, valleys, and rivers, along with the roads and railroad tracks that followed them, facilitated the division of residential areas along social, racial, and ethnic lines. As a result, Pittsburgh neighborhoods have traditionally been characterized by strong ethnic divisions. Remnants of these divisions continue to this day.

Because of the language handicap, homesickness, and pride, most Polish immigrants gathered together in neighborhoods that soon became Polish neighborhoods. With the great wave of Polish migration to Pittsburgh beginning in 1870, most Poles settled in four areas of the city: the Strip District, Lawrenceville, Polish Hill, and the South Side. The settlement pattern of Polish immigrants in Pittsburgh is in stark contrast with that in Philadelphia. While the clusters of settlements in both cities were linked to nearby industrial employers, the Poles immigrating to Philadelphia settled in 12 different sections of the city. Consequently, the Poles in Philadelphia were more likely to live among other ethnic groups.

Poles from the German section of partitioned Poland were the first Polish immigrants to arrive in Pittsburgh. Since they had a familiarity with the German language, these immigrants settled in the Strip District, a German neighborhood. They worked at Heppenstall's Forge, Carnegie Steel, Pittsburgh Machine Company, and other firms. Their settlement then spread to Lawrenceville and Polish Hill and finally to the South Side near the Jones and Laughlin Steel Mill and the Oliver Iron Works. In the late 1890s, Poles emigrating from the Russian and then the Austro-Hungarian sectors of Poland took residence alongside the German Poles in Lawrenceville and the South Side.

Poles, like other immigrant groups of the late 19th and early 20th centuries, used family and friends to obtain employment. Fathers helped sons find jobs, mothers helped daughters, and friends helped friends. Many industrial foremen valued the work ethic of the Polish immigrants they supervised, so they welcomed requests for employment of their relatives. This hiring practice helped the Poles establish networks of family and friends in the workplace. For the immigrants, their ability to acquire homes and build a community was greatly enhanced by their ability to establish these kinship systems in their workplaces.

Young Polish women worked at light industrial jobs, in restaurants, and as domestic help for wealthier families. Like the boys, they were expected to assist their parents and families financially. When women married, they usually left work to become homemakers, but it was not uncommon for adult Polish children to continue to live in the same house with their parents for many years after marriage. Several generations of relatives often inhabited the family home. The typical household contained a married couple, their young children, and one married son or daughter with a spouse and infant child. Often, there was an unrelated boarder living in the house as well.

Work dominated the lives of Polish immigrants. Family patterns, neighborhood life, and status within the community all depended on the ability to hold a steady job. While religious education

was considered important, the high value of steady work within the Polish community did not encourage strong support for other education. In the hierarchy of Polish values, work and family came before education. Older relatives encouraged young family members to get a job and help out. Polish youth typically quit school after the eighth grade, obtained jobs, and put all of their earnings back into the family, at least until they married. The young gave all of their earnings to their mother, who was traditionally the manager of Polish family finances. In return, the family provided food and shelter.

Many Polish immigrants were considered "birds of passage." They intended to earn and save money in the United States and then return home to Poland. Austro-Hungarian and Russian Polish immigrants consisted mainly of single men, many of whom expected to return to the homeland. German Poles, on the other hand, tended to immigrate in family units and were less likely to leave the United States than the other Polish immigrant groups.

In the early part of the 20th century, home ownership was the most highly valued form of wealth and status for the Polish immigrants, who were typically unskilled workers. Home ownership provided a way to keep the family together and achieve a modicum of economic security. This mindset was not surprising, since many Polish immigrants came from agricultural areas in the Old Country where status was based on ownership of land. Once acquired, a home was rarely abandoned. Even in death, a home was not sold but typically passed on to one's children as the family inheritance.

Home ownership was also a source of income for families that took in boarders, which occurred frequently. Furthermore, it was common for Polish immigrants to build second homes at the rear of their lots after the first house was paid off to provide another source of income. This offered security in old age before pensions were common and social security had been instituted. The rear house could also be used as a starter home for newly married children.

It was not uncommon in the early 1900s for Polish family groups to live in close proximity to each other in the same ethnic neighborhood. The strong dependence on family and friends, the feeling of belonging, the social and economic services provided by the community, and the close proximity to work encouraged many second-generation Polish Americans to settle in the neighborhood of their youth.

The harsh industrial conditions of Pittsburgh, as in other industrial American cities, took a toll on the health and wellbeing of all of its inhabitants, including the Polish immigrants. There was short life expectancy, high infant mortality, numerous industrial accidents (often fatal), heavily polluted air, poor quality drinking water, infectious diseases like tuberculosis, sporadic economic downturns, and a never ending struggle for the family just to make ends meet financially. The environment in Pittsburgh, with its fire, smoke, and soot in the air, was aptly summed up by the English observer James Paton in 1868 when he described the city as "Hell with the lid off."

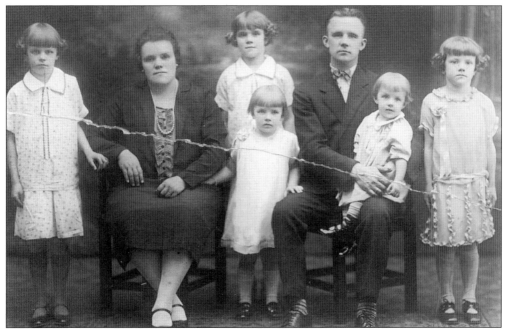

BIK FAMILY. This is a 1920 photograph of the Bik family of Polish Hill. Everyone in this picture was born in America. The paternal grandparents (not shown) immigrated to Polish Hill in the early 1900s from the Rzeszow region in southeastern Poland. These grandparents worked in the factories in the Strip District including Kress Box and the Armstrong Cork Companies. The grandparents eventually retired back to the family farm in Poland after earning a pension here. The individuals in this photograph are their children and grandchildren; from left to right are Ruth, Mary (mother, seated), Isabelle (rear), Irene (front), Walter (father, seated), Florence (on father's lap), and Laura. The five children in this photograph were the first of eight. (Kozlowski family.)

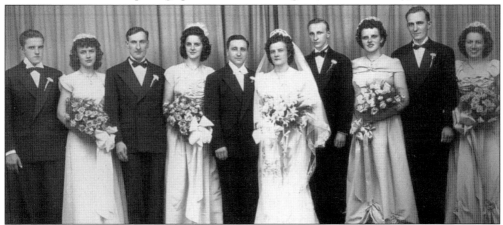

KOZLOWSKI-BIK WEDDING. Florence Bik (youngest daughter in the previous photograph) married Stanley Kozlowski in the Immaculate Heart of Mary Church on Polish Hill in 1950. The wedding reception was held at the Polish Falcons Hall on Brereton Avenue, a couple of doors down the street from the church. The married couple then settled on the North Side (the groom's neighborhood) and raised their own family. From left to right are Walter Bik, Ruth Dominiak, Alex Checinski, Irene Bik, Stanley Kozlowski (groom), Florence (Bik) Kozlowski (bride); Chaz Kozlowsk, Virginia Bik, Stanley Swiatek, and Cecelia Dominiak. (Kozlowski family.)

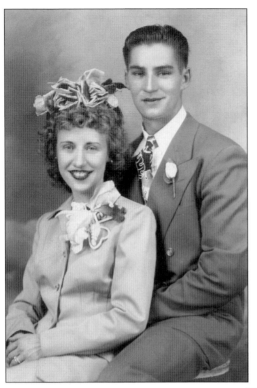

WEDDING OF HENRY AND ANN GOLIAT. This is a photograph from the 1948 wedding of Henry "Lefty" Goliat and Ann Brezezinski on Polish Hill. The bride's father was Jacob Brzezinski, who was born in Poland. Of all of Pittsburgh's neighborhoods, Polish Hill has retained its ethnic character the most strongly. Around 1880, frame houses began to be built on 139 acres of undeveloped land on the northeast end of Herron Hill, on the slope overlooking the Strip District and Lawrenceville. This area was originally known as Springfield Farm. The Polish settlers referred to their neighborhood as Polskie Gory (Polish Hill). It was said that the Polish immigrants favored settling on the hill above Pittsburgh to be closer to God. By 1895, there were so many Polish immigrants living on this plot of land that the official name of this section of the city was changed from Herron Hill to Polish Hill. (Goliat family.)

GRANDFATHER AND FATHER. John Iwinski (left) is the maternal grandfather of the groom in the previous image. With him is John Henry Goliat, father of the groom. The location is Polish Hill in the 1940s. (Goliat family.)

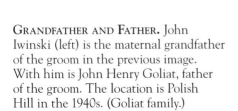

GOLIAT GRANDCHILDREN. Ann Goliat, the bride pictured on the opposite page, is seen here with her children Henry and Fran Goliat on Polish Hill in 1955. Some of the houses on Polish Hill were built on such steep slopes that they could only be reached by wooden or concrete steps. The land was cheap and close to job sites in the Strip District and Lawrenceville. The original residents of Polish Hill were mostly immigrants from the German-controlled portion of partitioned Poland. (Goliat family.)

TWO SISTERS-IN-LAW. Ann (Brezezinski) Goliat (left) is pictured with her sister-in-law Irene (Goliat) Sica on Polish Hill in the 1950s. Note the outdoor privy that was still in use in the early 1950s. City housing code did not actually require bathrooms in homes and apartments until sometime in the 1950s. Polish Hill was self-sufficient, containing about 50 businesses. The neighborhood had its own grocery stores (including an A&P and a Kroger), bars, a pharmacy with a soda fountain, doctors and dentists who spoke Polish, candy stores, tailors, funeral parlors, hardware stores, dry goods stores that sold clothes, bakeries, shoe stores, and a theater. Residents bragged that they never had to leave the Hill for their needs. Other Polish neighborhoods, like the South Side, also had Polish business districts. There are currently about a dozen businesses operating on Polish Hill, several of which, like Lili Coffee Shop, have just opened in the past few years. (Goliat family.)

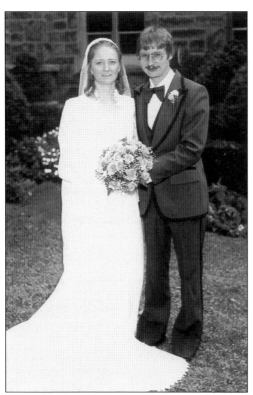

HENRY AND KATHLEEN GOLIAT WEDDING.
The wedding of Kathleen and Henry Goliat
on August 18, 1979, is seen here. Henry
is a Vietnam veteran and the son of the
couple pictured on page 34. (Goliat family.)

COLLEEN AND CATHERINE GOLIAT.
Colleen (left) and Catherine Goliat
are the daughters of Kathleen
and Henry Goliat, seen in the
photograph above. (Goliat family.)

TOM AND MARY (LUBASIK) URBANIAK. Tom was the first Urbanik born in the United States. He was born on Polish Hill in 1905 with the aid of a midwife. His parents were Vincent and Johanna Urbaniak, both born in Poland. Mary's parents were John and Frances Lubasik. (Urbaniak family.)

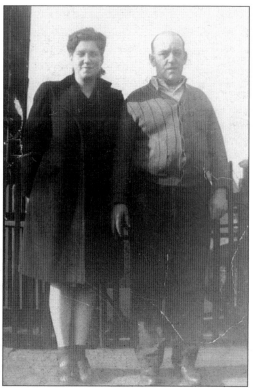

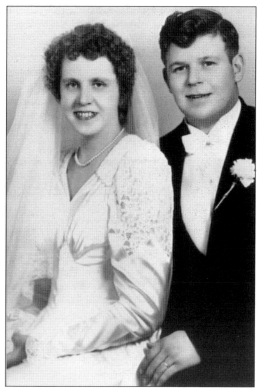

WEDDING OF JOHN AND DOROTHY URBANIAK. The wedding of John Urbaniak and Dorothy Schultz took place on Polish Hill. John was the son of Tom and Mary Urbaniak, pictured above. (Urbaniak family.)

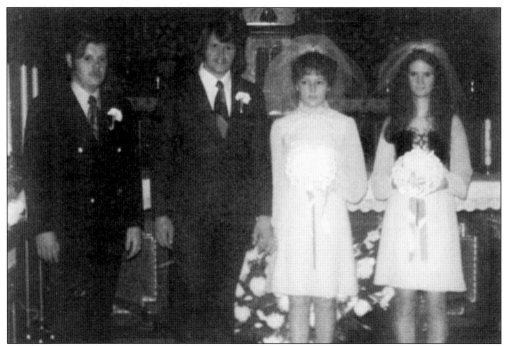

Gregory and Frances Urbaniak Wedding. The wedding of Greg (a Vietnam veteran) and Fran (Goliat) Urbaniak took place in the Immaculate Heart of Mary Church on Polish Hill in 1972. Greg is the son of the couple on the previous page. Greg and Fran still reside on Polish Hill in 2017. (Urbaniak family.)

Becky and Vicky Urbaniak. Rebecca (left) and Victoria Urbaniak are the daughters of Greg and Fran Urbaniak. They also still live on Polish Hill. (Urbaniak family.)

CHRISTOPHER SIMPSON AND ELIJA REDWOOD. These are the sons of Vicky and Becky Urbaniak, respectively. They reside on Polish Hill and attend St. Raphael's Catholic Grade School in the nearby Morningside neighborhood of Pittsburgh. (Urbaniak family.)

LAUNDRY DRYING ON POLISH HILL. Neighborhood ladies are hanging linens out to dry on a Polish Hill sidewalk. The Immaculate Heart of Mary Church cupola appears in the background. Many of the Polish immigrants lived in slum-like conditions. Entire families lived in one room, sometimes accommodating boarders in a corner. *Sklepowe izby* (cellar rooms) were occupied by families whose income did not permit them to live in the more expensive first-floor quarters. (Carnegie Library of Pittsburgh.)

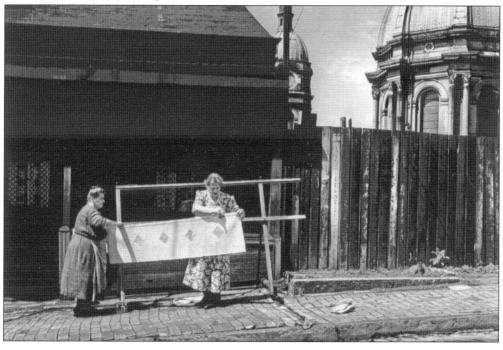

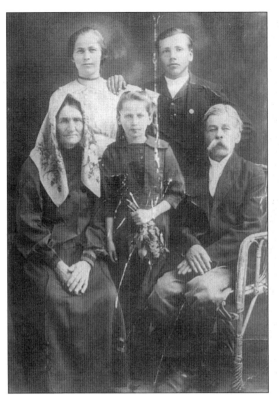

SIERAGO FAMILY IN POLAND. The Sierago family is pictured here in Zolynia, Poland, around the early 1900s. The mother (wearing a babushka) is Margaret (Doleugo) Sierago, and the father (with a mustache) is Joseph Sierago. The daughter standing in back was Nellie Sierago, born in 1892. Nellie emigrated from Poland to Pittsburgh in July 1910. She sailed on the *Rotterdam* and arrived in Baltimore. (Lis family.)

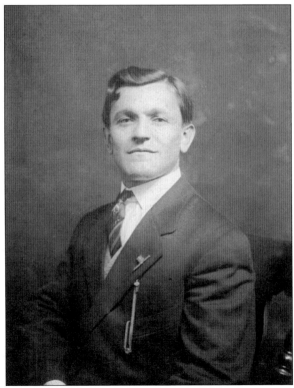

JOSEPH LIS. Joseph, born in Poland, married Nellie Sierago in Pittsburgh on May 6, 1914. (Lis family.)

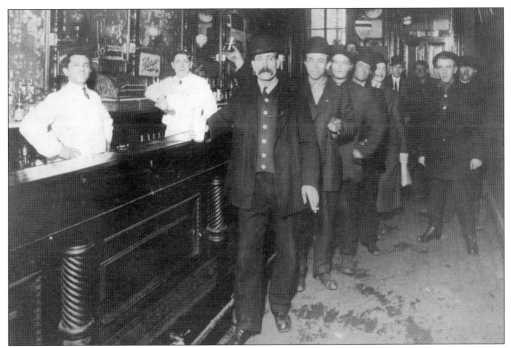

BARTENDER ON BUTLER STREET. Joseph Lis first worked as a bartender on Butler Street in Lawrenceville around 1915. (Lis family.)

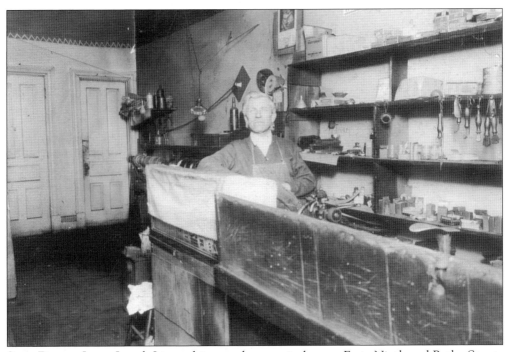

SHOE REPAIR. Later, Joseph Lis ran his own shoe repair shop on Forty-Ninth and Butler Streets in Lawrenceville for many years. (Lis family.)

CHILDREN ON PONY. Joe and Nellie Lis's children Theodore and Mary are shown riding a pony on McCandless Street in Lawrenceville in the late 1920s. (Lis family.).

FATHER AND SAILOR SON. Joe Lis is pictured here with his son Theodore, who joined the US Navy in the 1940s. (Lis family.)

Joseph Statkiewicz. Joseph Statkiewicz (born in Poland in 1872) settled with his wife, Josephine (also born in Poland), in Pittsburgh in 1911. They lived on Polish Hill, in the Strip District, and finally, on the North Side. Joseph and Josephine have been succeeded by five generations of Polish American Pittsburghers with a family home still on Avery Street on the North Side of the city. (Warrick family.)

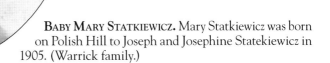

Baby Mary Statkiewicz. Mary Statkiewicz was born on Polish Hill to Joseph and Josephine Statekiewicz in 1905. (Warrick family.)

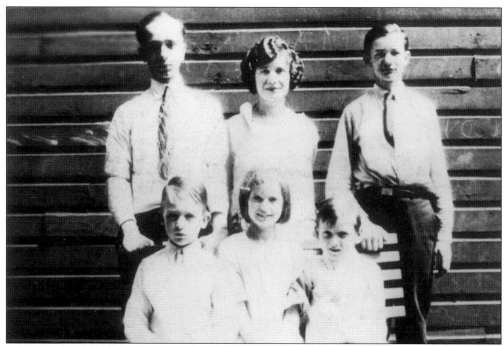

STATKIEWICZ CHILDREN. The Statkiewicz children are pictured in either the Strip District or the North Side of Pittsburgh in the 1920s. Some of the children were born in Poland and some in Pittsburgh as the family traveled back and forth between the two countries during the early years of the 20th century before finally settling in Pittsburgh. From left to right are (first row) John, Stella, and Tom; (second row) Joe, Mary, and Stanley. (Warrick family.)

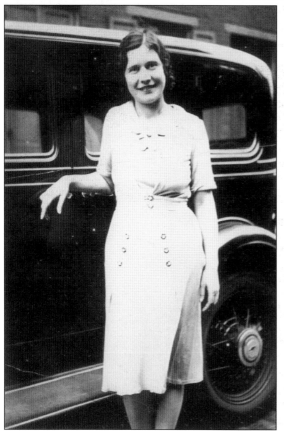

MARY STATKIEWICZ. Mary Statkiewicz is pictured on the North Side in the mid-1920s. (Warrick family.)

STATKIEWICZ-ROSENFELD WEDDING.
This is a wedding photograph of Mary
Statkiewicz and Fred Rosenfeld. The best
man is the brother of the bride, Joseph
Statkiewicz. The maid of honor is the
sister of the groom. The wedding took
place in St. Peter's Church on the North
Side on July 28, 1925. (Warrick family.)

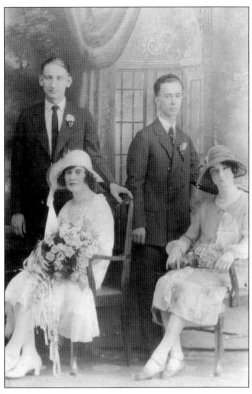

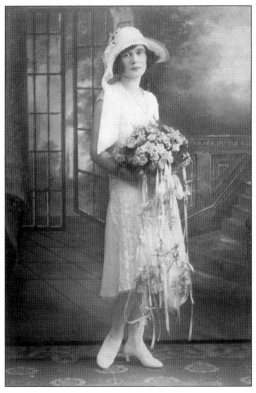

MARY STATKIEWICZ BRIDAL PHOTOGRAPH.
Mary Statkiewicz is pictured here on her
wedding day in 1925. (Warrick family.)

AUDREY WARRICK. Audrey (Rosenfeld) Warrick, Mary's daughter, is shown standing in front of the family home on Avery Street on the North Side in 1955. The house was built in the 1880s and was purchased by the family in the late 1920s. Audrey still lives in that home. Four generations of the Statkiewicz/ Rosenfeld/Warrick family have lived there. Additionally, Audrey's grandchildren and great grandchildren continue to visit her in the family home. (Warrick family.)

FATHER COX'S MARCH. Times were tough in Pittsburgh during the Depression. Then-23-year-old Stanley Statkiewicz (wearing a bow tie and holding a man on his shoulders) participated in Father Cox's March in 1932. After serving as a US Army chaplain in France in World War I, Fr. James Renshaw Cox served as the pastor of Saint Patrick's Church in Pittsburgh's Strip District. During the Depression, he organized a food relief program and helped the homeless and unemployed find shelter. In January 1932, Father Cox led a march of 25,000 unemployed Pennsylvanians, known as "Cox's Army," on Washington, DC. He hoped to encourage the government to start a public works program. This was the largest demonstration until that time in the nation's capital. (Stanley States.).

STANLEY STATES AS SOLDIER. Stanley (Statkiewicz) States was born in Krakow, Poland, in 1909. He migrated to this country with his parents, brothers, and sisters in 1911. He always told his children that the United States was the best country in the world. He proudly served in the US Army National Guard in the 1930s and also served in the US Army Air Corps in the Philippines and New Guinea during World War II. (Stanley States.).

RUDINSKI FAMILY FARM. Most Polish immigrants living outside of the cities in Southwestern Pennsylvania were coal miners. Poles and Slovaks constituted about a third of the workforce in the bituminous coal mines in Allegheny, Fayette, and Westmoreland Counties in 1910. Frank Rudinski was a foreman in the coal mines. In addition to mining, he and his family also farmed. In this early 1930s photograph, he is shown on his 65-acre farm in Vestaburg just south of Pittsburgh with his wife, Jenny, his daughter Millie, and his son Frankie. Frank and Jennie were both born in Poland but were married in this country. Sadly, their son Frankie was killed in action about 10 years later during World War II. (Stanley States.)

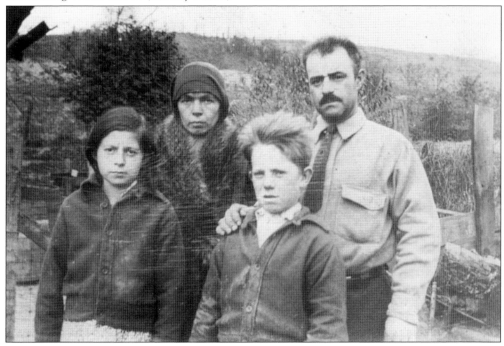

MILLIE RIDING A MULE. Daughter Millie Rudinski is shown here riding a mule on the farm. She later graduated from Chatham College in Pittsburgh, married a college professor, and settled in Connecticut. (Stanley States.)

STANLEY STATKIEWICZ MILKING A COW. Stanley Statkiewicz milks a cow on his aunt Jenny Rudinski's farm. (Stanley States.)

FATHER AND DAUGHTERS. This 1923 photograph shows Adam Wojda with his older daughter Wanda and his younger daughter Albina. Adam was born in Labunie, Poland, in 1885. He immigrated to the United States in 1910 and moved to Montreal to work in the lumber industry. Within a year, he moved to Pennsylvania and became a mule runner on the Erie Canal, leading mules and draft horses pulling boats along the tow paths. Adam's wife Aniela (not pictured) liked to reminisce about their Old County wedding. Adam and Aniela were married in the old stone church in the village of Zawalow, Poland, in 1905. The celebration lasted three days with feasting, music, singing, and dancing. Women cooked in the kitchen and set the food on the window sill to be served to the guests either outdoors or in the barn. Aniela recalled that the cow grazing nearby tried to eat the food several times, and even approached the wedding cake. (Lane family.)

RICHARD RZACA. Rzaca, "the Kolbassi King of Western Pennsylvania," was born on Polish Hill in Pittsburgh in 1927 and attended Immaculate Heart of Mary School. He served in the US Army artillery during World War II in the Pacific. Upon his discharge, he joined the family business, Arsenal Sausage Company, which had been started by his father who immigrated to this country from Poland. In 1964, Richard and his wife, Eleanor, started their own meat-processing business, Silver Star Meats, which is still located in McKees Rocks, just outside of the Pittsburgh city limits. Their company manufactures Polish specialties as well as hams and sausages. (Rzaca family.)

49

RICHARD RZACA'S FATHER'S DIPLOMA. Richard Rzaca's father, Czeslaw (Chester), who started the family meat-processing business, received a diploma from the Warsaw Institute of Master Sausage and Processing Meats in 1910. The diploma is written in both Russian and Polish since Warsaw was located within the sector of partitioned Poland controlled by Russia at that time. The diploma is currently on display in the Heinz History Center in Pittsburgh. (Rzaca family.)

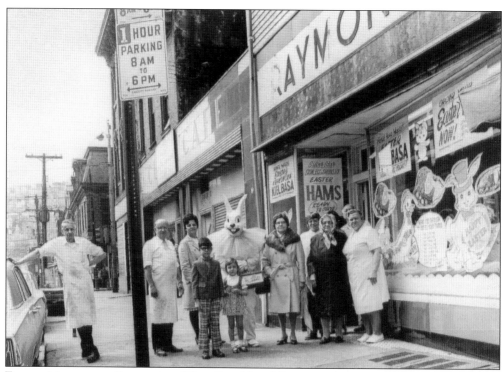

EASTER MARKETING PROMOTION. Silver Star Meats' Easter marketing promotion at Raymond's Market on Pittsburgh's South Side is seen here. The Easter Bunny was Richard's daughter Carolyn Rzaca. (Rzaca family.)

RICHARD AND ELEANOR RZACA. Richard Rzaca and Eleanor Nowacynski-Rzaca were given the Outstanding Polonians of the Year award by the Kosciuszko Foundation in 2003. Over the years, they were enthusiastic supporters of many Polish activities and supported many ethnic radio programs. They also hired numerous displaced persons from Eastern European countries to help them get a start in America. Anticipating their retirement, in 1993, Richard and Eleanor formed a stock ownership plan for their employees, giving them full ownership of Silver Star Meats. (Rzaca family.)

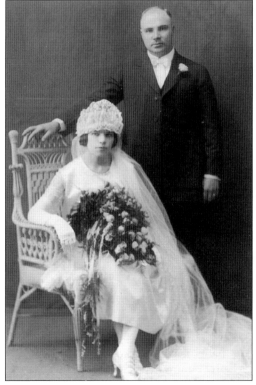

JESKEY WEDDING. Marion Stasilaunis and John (Jezewski) Jeskey are pictured on their wedding day in 1920. They were married in St. Wenceslaus Church (Bohemian Church) on the North Side. John was born in Poland while Marion was born in Pittsburgh. Marion's maiden name, Stasilaunis, is Lithuanian. (Jackson family.)

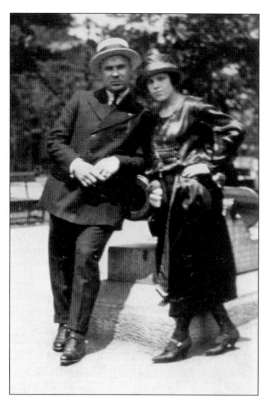

JESKEYS IN WEST PARK. Marion Jeskey and her husband, John, dressed in their finery, pose by the cannon in West Park on the North Side in the early 1920s. When Marion was a young girl, she worked in a cigar factory in Pittsburgh rolling Marsh Wheeling Mild Stogies. (Jackson family.)

MARION JESKEY ON A SWING. Marion Jeskey and her husband, John, are pictured at a picnic in the early 1920s. John initially worked as a coal miner and later as a steelworker. (Jackson family.)

BABY BERNIE JESKEY. Five-month-old Bernadine "Bernie" Jeskey, daughter of John and Marion Jeskey, is pictured on the North Side of Pittsburgh in 1923. (Jackson family.)

BERNIE JESKEY'S COMMUNION. Bernie Jeskey's First Holy Communion took place in 1930. (Jackson family.)

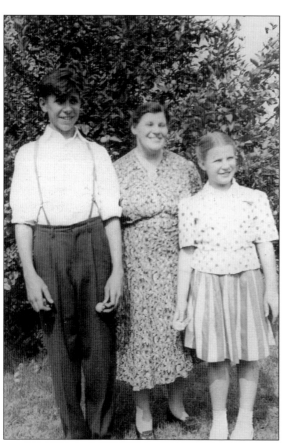

MARION JESKEY WITH JACK AND RUTH. Pictured here is Marion Jeskey with her other two children, Jack and Ruth, in 1942. Marion was a North Side resident her entire life. (Jackson family.)

MARION JESKEY WITH GRANDDAUGHTER GERRI. Marion Jeskey is with her granddaughter Gerri Jackson in 1984. Marion was always known to her grandchildren as "Nanny." She lived to be 96 years old. (Jackson family.)

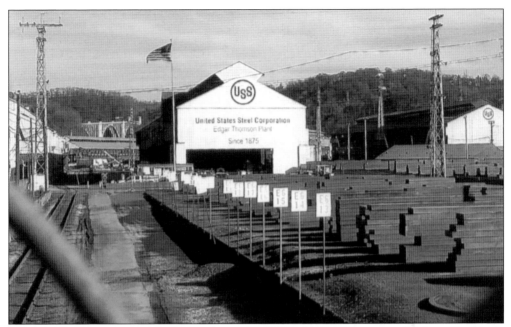

US Steel Edgar Thompson Works. This is the US Steel Edgar Thompson Works in Braddock. This mill is still operating and producing specialty steel. As the sign on the building indicates, the plant has been in operation since 1875. Many Polish immigrants in the 19th and 20th centuries worked at this site and at a number of other steel mills within and surrounding the city of Pittsburgh. (Stanley States.)

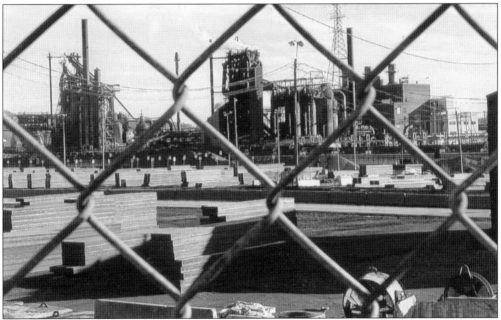

The Steel Mill Industry. Approximately 60 percent of the Poles who settled in Pittsburgh worked in the steel mills, in unskilled or semiskilled positions. Eastern Europeans typically worked in the open hearths, which involved the longest hours and the highest risk of accident. Other Eastern Europeans worked in the area's glass industry. (Stanley States.)

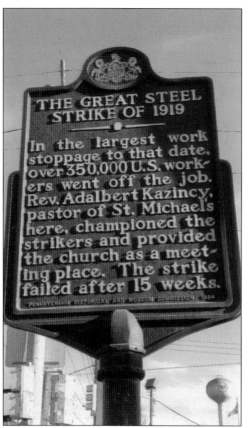

THE GREAT STEEL STRIKE OF 1919. This plaque outside the main gate to the US Steel Edgar Thompson Works, commemorates a major strike in the early days of steel production. A typical workweek in the mills consisted of five 12-hour days and one 6-hour day. Sometimes, the workers were forced to work the dangerous 24-hour "long turn," where accidents involving molten steel and machinery were frequent. A typical salary was $12.50 per week. Workers received no sick days, vacation days, or health benefits. (Stanley States.)

UNION HALL. First- and second-generation Polish Americans typically joined the labor movement. They supported the steelworkers' unionizing efforts in steel plants in Pittsburgh in the 1930s. Many rose to leadership positions within the unions. The harsh industrial environment in cities like Pittsburgh took a tool on the immigrants. High infant mortality, industrial accidents with deaths, economic setbacks, and the constant struggle to obtain decent living conditions were common to the lives of Polish immigrants as well as those from other countries and African American immigrants from the South. (Stanley States.)

IGNATZ AND LEOKATIA STATKIEWICZ AND THEIR SON JOSEPH. Ignatz and Leokatia Statkiewicz are pictured above in Mlawa, Poland (north of Warsaw), in the 1890s. The two never left Poland. Joseph Statkiewicz (right), their son, was born in Poland. He met and married his wife, Josephine (also born in Poland), in Utica, New York, in the early 1900s. After returning to Krakow, Poland, where Josephine attended midwifery school, they finally settled in Pittsburgh. At one point, Joseph was a milkman, delivering milk from a horse-drawn wagon. However, he spent most of his life in Pittsburgh working as a baker. Josephine practiced midwifery on Polish Hill. She had a sign in her front window reading, "European Trained Midwife." (All, Stanley States.)

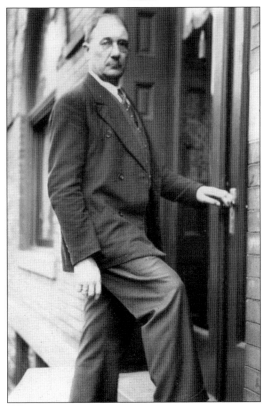

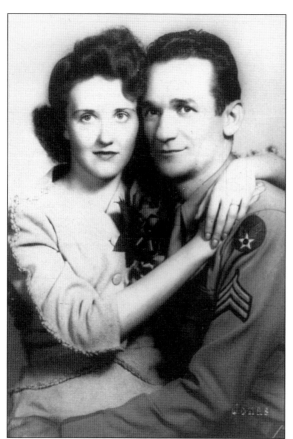

STANLEY AND CATHERINE STATES. Stanley (Statkiewicz) States was Joseph and Josephine's son. In this photograph, Stanley had just married Catherine McGladrigan in St. Peter and Paul Church in the East Liberty section of Pittsburgh. They were married in 1943 while Stanley was on furlough from the US Army Air Corps. Stanley later shipped out to the South Pacific. (Stanley States.)

TWO MORE GENERATIONS. From left to right, Stanley Jerome States (son of the Stanley above) and his wife, Kathleen (Price) States, look on while Meliheh (Mousavizadeh) marries their son Stanley Thomas States. Stanley Thomas's brothers Michael and Joseph are on the right. (Stanley States.)

BABY LENA. Lena Catherine States represents the sixth generation of the Statkiewicz/States family. She was born on October 7, 2016, to Stanley Thomas and Meliheh States and is fully Americanized. Her ethnic lineage includes Polish, Irish, Iranian, English, Scottish, and German. However, she obviously cherishes her Polish heritage. Her Polish shirt reads, "I love my Grandpap." This book is dedicated to her. (Stanley States.)

RUDIAK FAMILY, 1911. The parents in this image were married in Poland, and the family eventually settled in Lyndora, Pennsylvania (near Butler, just north of Pittsburgh). Pictured are Jan Rudiak (father), Jadwiga Wolk Rudiak (mother), and Joseph Rudiak (baby on lap). (Rudiak family.)

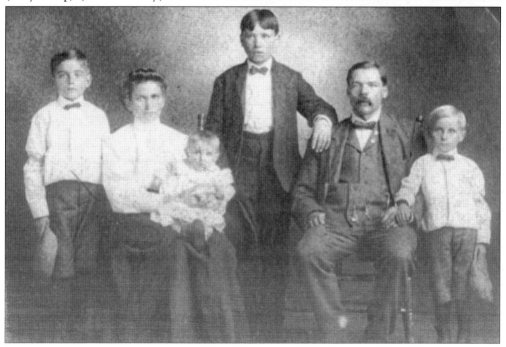

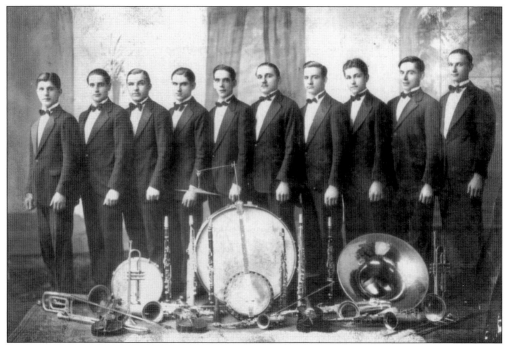

THE 7 RUDIAK BROTHERS ORCHESTRA, 1925. The Rudiak family lived in Lyndora. The 7 Rudiak Brothers Orchestra played in Lyndora, Pittsburgh, and other locations in Western Pennsylvania. Their mother encouraged all seven sons to learn an instrument to help the family financially. (Rudiak family.)

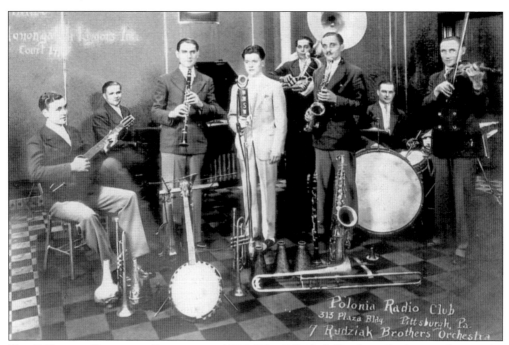

THE 7 RUDIAK BROTHERS ORCHESTRA, 1936. The 7 Rudiak Brothers Orchestra plays at the Polonia Radio Club in Pittsburgh on WWSW Radio. (Rudiak family.)

THE BAKOWSKI FAMILY. This family picture was taken on the South Side in 1925. From left to right are (first row) daughters Regina and Clara Bakowski; (second row) father Jan, wife Adamina, and daughter Sophia Bakowski. (Rudiak family.)

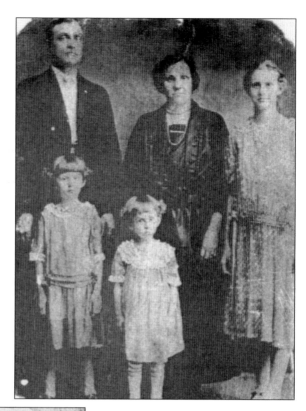

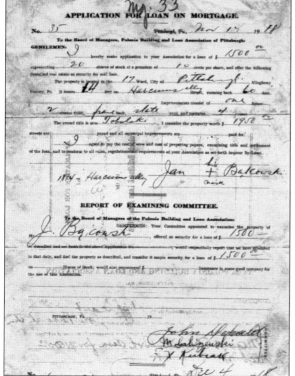

MORTGAGE APPLICATION. This is Jan Bakowski's 1918 mortgage application to purchase the family home at 1814 Harcum Alley on the South Side. Jan applied for a loan of $1,500 for a house valued at $1,950. The mortgage agency was the Polonia Building and Loan Association of Pittsburgh. It is interesting to note that Jan signed this application with an "X," which the clerk certified was "his mark." (Rudiak family.)

CENSUS RECORD FOR BAKOWSKI FAMILY, 1920. This is the 1920 census record for the Bakowski family living on Harcum Way on the South Side. (Rudiak family.)

JAN BAKOWSKI SITTING ON THE STOOP. This is a 1945 photograph of Jan Bakowski sitting on the stoop of the family home at 1908 Jane Street on the South Side. Jan, who came to this country from Poland in 1907 and worked as a laborer at J&L Steel on the South Side, purchased this house in 1928, one year before the Great Depression. Times were so hard during the Depression that Jan's children all had to go to work to earn enough money to avoid losing the family home. (Rudiak family.)

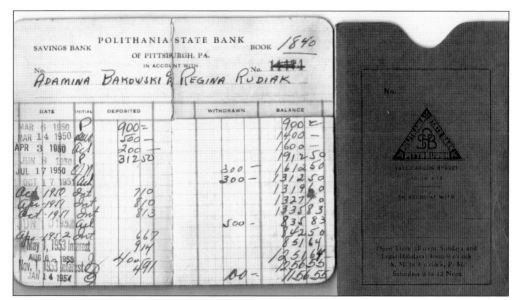

POLITHANIA BANK BOOK. This is a 1950 bank book for Adamina Bakowski and her daughter Regina Rudiak from the Polithania State Bank on the South Side. As the name indicates, the Polithania Bank was originally established to serve the needs of Polish and Lithuanian immigrants. (Rudiak family.)

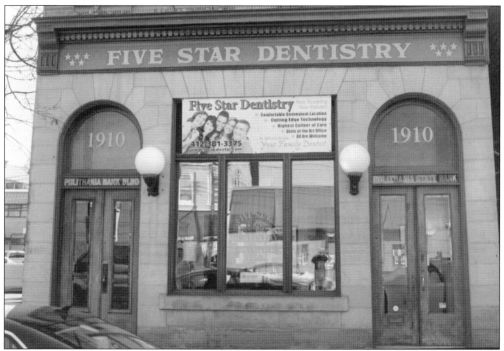

POLITHANIA BANK BUILDING. The original Polithania Bank building, with the bank's name over the door as a nostalgic reminder of the past, still stands at 1910 Carson Street. As the photograph indicates, the building now serves the community by housing a dental office. (Rudiak family.)

THE RUDIAK FAMILY, 2014. From left to right are father John, mother Helena, and their children Barbara, Natalia, and John Rudiak; Margaret Rudiak had passed away earlier. Natalia currently serves as a councilwoman for the City of Pittsburgh. (Rudiak family.)

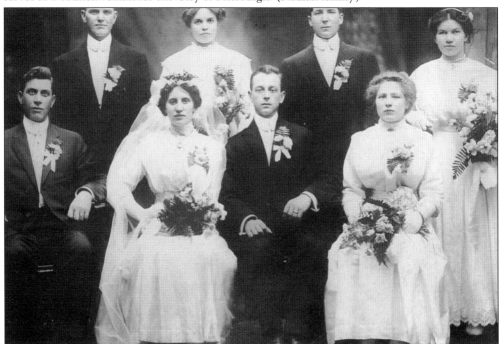

CZACHOWSKI-KINGERSKI WEDDING. This wedding photograph of Victoria Czahowski and Stephan Kingerski was take in 1913 in Detroit, Michigan. The bride and groom later relocated to Slickville, Pennsylvania just east of Pittsburgh, where Stephan worked as a coal miner for the Irwin Gas-Coal Company. The couple had four children. Unfortunately, Stephan, who was born in Poland in 1885, was killed in an accident in the mine in August 1923 when he was crushed by a piece of falling slate. (Radovich family.)

KINGERSKI-RADOVICH WEDDING.
Now widowed, Victoria Kingerski
married John Radovich in
1925. (Radovich family.)

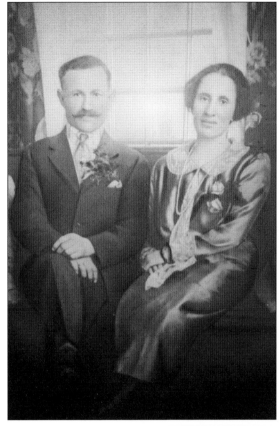

**KINGERSKI-RADOVICH BLENDED
FAMILY.** This 1926 family photograph
shows the blended family of Victoria's
second marriage. From left to right
are father John Radovich, Helen
Kingerski, Francis Kingerski, Harry
Kingerski, Walter Kingerski, baby
John Radovich, and mother Victoria
Radovich. (Radovich family.)

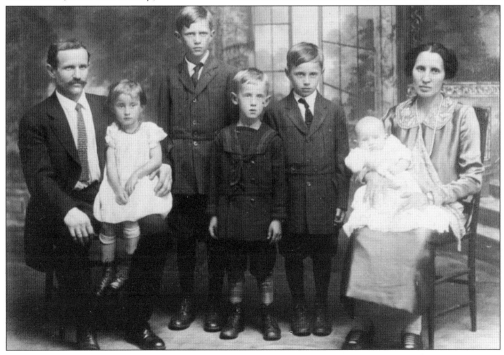

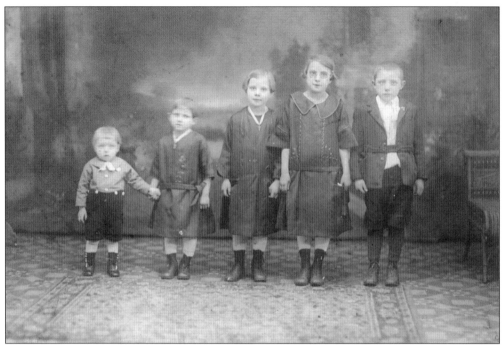

KRUSZEWSKI CHILDREN, 1920. From left to right are Peter, Stella, Harriet, Josephine, and Charles. (Lisowski family.)

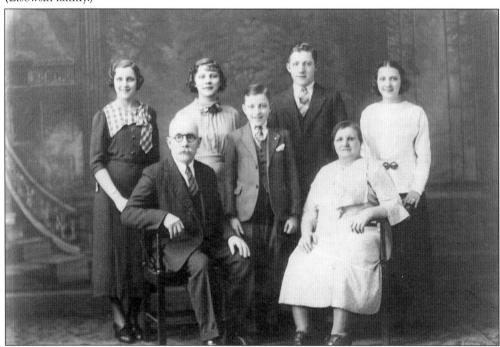

KRUSZEWSKI FAMILY, 1937. From left to right are (first row) father Joseph and mother Appolonia; (second row) children Stella, Harriet, Peter, Charles, and Josephine. The father and mother were both born in the Bialystok area of Poland. They immigrated to this country in the early 1900s and were married here. The father worked in a steel mill in Lawrenceville. (Lisowski family.)

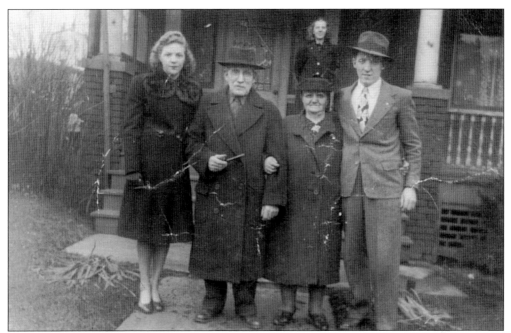

KRUSZEWSKI FAMILY, 1939. From left to right are Helen (wife of Charles, who was one of the Kruszewski sons), father Joseph, mother Appolonia, and son Peter; daughter Harriet is in the background. This photograph was taken at aunt Josephine Kruszewski's house on Black Street in Stanton Heights. (Lisowski family.)

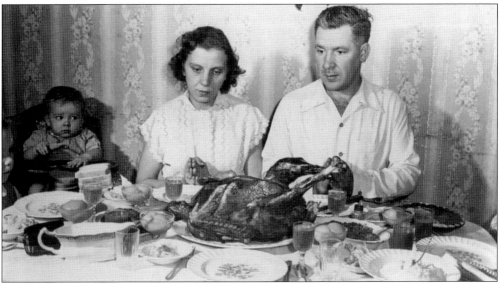

LISOWSKI FAMILY THANKSGIVING DINNER, 1947. Pictured here are mother Harriet Kruszewski Lisowski, father Anthony Lisowski, Marylin (child on far left), and Paul (child in highchair). This photograph was taken in the Lisowski home on Forty-Fifth Street in Lawrenceville. Anthony worked at several steel mills over his lifetime. When one mill closed, he moved on to another. Sadly, he died in a mill in 1962 when he was only 40 years old. After his shift, he was found dead on the floor. It was never clear whether his death was due to natural causes, an injury on the job, or a combination of both. However, he left behind a young family. (Lisowski family.)

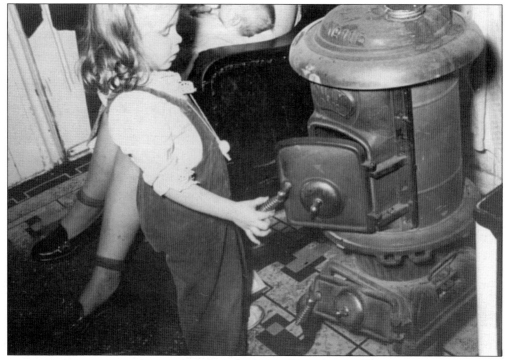

Coal Stove. This is a 1949 picture of young Marylin Lisowski in the Forty-Fifth Street family home in Lawrenceville. The Franklin coal stove was used for heat. (Lisowski family.)

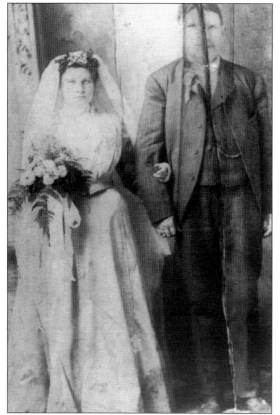

Czekala Wedding. The wedding of Pavel "Paul" Czekala to Stanislawa "Stella" Pawlik took place in 1905. Pawel emigrated from a town north of Warsaw, Poland, in 1898. Stanislawa emigrated from Czestochowa, Poland, in 1900. The couple met in this country. Pavel was a butcher. (Czekala family.)

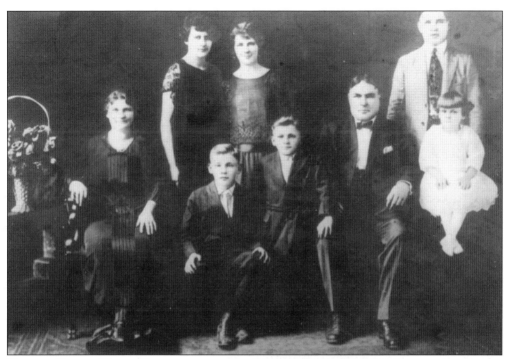

CZEKALA FAMILY. Pictured here are the mother, father, five children, and an uncle of the Czekala family in 1922. From left to right are (first row) Stanislawa (mother), Edward, Joseph, Pavel (father), and Eleanor; (second row) Sophie, Josephine, and Anthony Pawlak (Stanislawa's brother). Pavel and Stanislawa brought Anthony from Poland to this country. (Czekala family.)

FIRST HOLY COMMUNION. Sophie Czekala's first communion was in 1922. She is at right holding flowers; the other child is Eleanor, her younger sister. (Czekala family.)

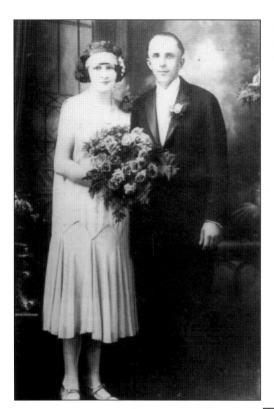

GUESTS AT A WEDDING. Josephine Czekala poses with a friend at a wedding in 1923. (Czekala family.)

BRIDESMAID, 1928. Sophie Czekala (16 years old) was a bridesmaid at this wedding in 1928. She caught a cold, possibly at the wedding, and died one week later. Her family said that she had walked home barefoot after the wedding and died of "galloping consumption." Perhaps this was pneumonia that could have been treated with antibiotics when they became available 15 years later. Life was often shorter at the time. (Czekala family.)

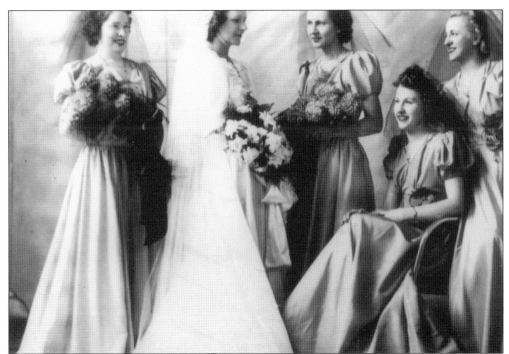

BRIDE, 1938. Eleanor Czekala married John Foley in 1938, and the couple had five children. Eleanor lived to the age of 64, and John died at age 72. (Czekala family.)

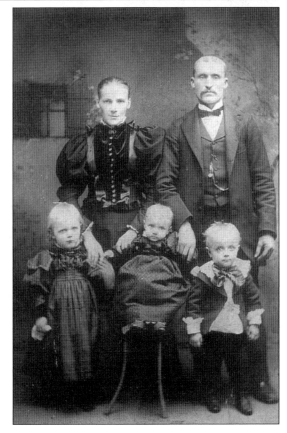

SUCHADUPSKI FAMILY. The Suchadupski family is pictured here on the North Side in 1897. From left to right are (first row) Stella, Pauline (on chair), and Cazmir; (second row) Katheryn (Andrejka) Suchadupska and John Suchadupski. Both parents were born in Poland, but all the children were born in Pittsburgh. (Konefal family.)

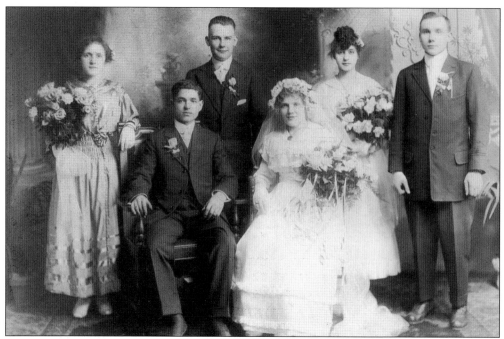

KONEFAL WEDDING. The wedding of Stella Suchadupska and Lawrence Konefal took place on the North Side on January 23, 1917. Stella was born in Pittsburgh, while Lawrence emigrated from the small town of Rzeszow (County of Ranizow) in Poland. The wedding party standing behind the bride and groom were, from left to right, Pauline (Suchadupska) Sulinska (sister of the bride), Joseph Mazurek (cousin), Valaria Elsie Suchadupska (cousin), and Joseph Majewski. Lawrence Konefal worked at a foundry in McKees Rocks, just west of Pittsburgh. (Konefal family.)

BABY STANLEY KONEFAL. Lawrence and Stella Konefal's first son, Stanley, is pictured on the North Side in 1919. (Konefal family.)

Four Konefal Children. Four of Lawrence and Stella's five children are pictured on the North Side of Pittsburgh in the late 1920s. The youngest son, Ray, had not yet been born. From left to right are (first row) Del and Charlie; (second row) Ted and Stanley. (Konefal family.)

Stella Konefal, 1989. Stella Konefal lived to be 97 years old. She was affectionately known to all of her grandchildren and great grandchildren as Babka, which translates to "Grandma" in Polish. (Konefal family.)

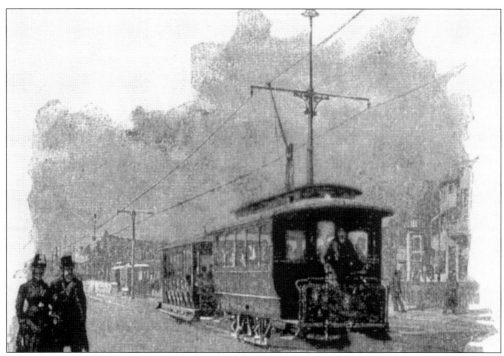

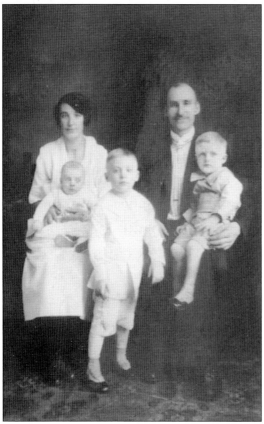

TROLLEY. Elizabeth Lucas was born in 1909 in Belle Vernon, Pennsylvania, to Martin Antal, a coal miner from Poland, and Agata Golema. Martin lost his first wife when she gave birth to their second child. He sent over to Poland for another wife, and Golema left her home in Krakow to join him, arriving in 1902. Elizabeth shared a bedroom with 11 siblings. She remembers walking miles to buy bread and milk. When she turned 13, she and other Mon Valley girls would get a ride on Mondays to Pittsburgh to "clean for rich people all week." Her schooling ended in sixth grade. On the weekends, she would ride the trolley home to Elizabeth Township and give all of her pay to her mother. (Stanley States.)

STANLEY AND SOPHIA CYPRYCH FAMILY. Stanislaus and Sophie (Yablonsky) Cyprych were both born in Poland. They were married in the United States and lived on Chatsworth Street in Hazlewood. Stanislaus came over in 1909 and worked for the Mon Valley Railroad. These three children were the first of eight. Edward is sitting on his mother's lap. The photograph was taken around 1920. (Cyprych family.)

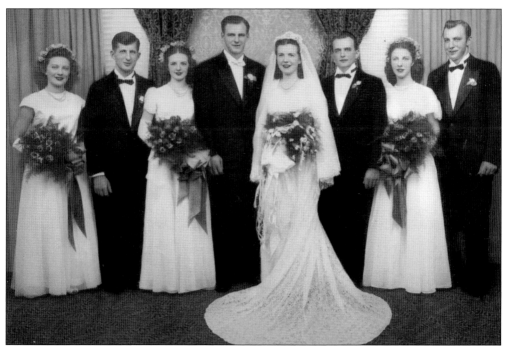

CYPRYCH-PRIBILA WEDDING. Edward Cyprych and Lydia Pribila were married on August 30, 1947, at St. Joachim's Church in Pittsburgh. Edward is the baby on his mother's lap on the opposite page. (Cyprych family.)

CARNEGIE-ILLINOIS STEEL CORPORATION

Edward W. Cyprych

has completed the course of Industrial Training as a *Carpenter* Apprentice as prescribed in the plants of the Corporation. In recognition thereof, this Certificate of Accomplishment is awarded by authority of the president of this company, Mr. C. R. Cox, on the recommendation of *(June 4, 1949)*

DISTRICT MANAGER OF OPERATIONS

VICE PRESIDENT, OPERATIONS

VICE PRESIDENT, INDUSTRIAL RELATIONS

GENERAL SUPERINTENDENT

CARPENTER APPRENTICE CARD. Pictured is Edward Cyprych's carpenter apprentice card in 1949. (Cyprych family.)

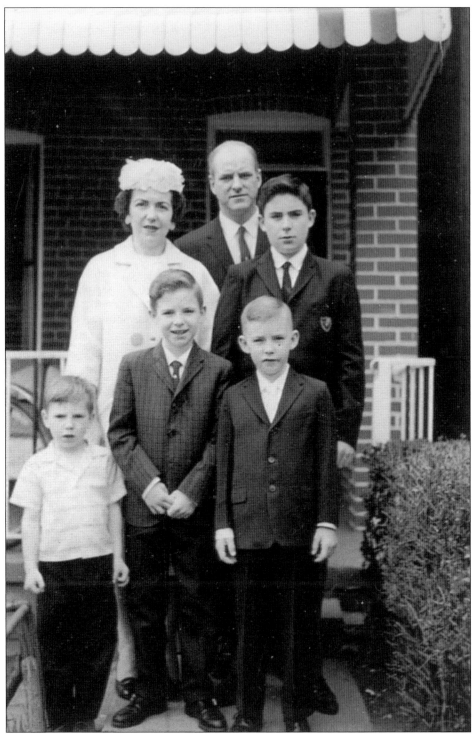

EDWARD CYPRYCH FAMILY. Seen here with parents Lydia and Edward are sons (from left to right) James, Eugene, Thomas, and Edward. This picture was taken on Kilbourne Street in Hazelwood in April 1962. (Cyprych family.)

Four

FRATERNAL SOCIETIES

When settling in American cities, ethnic groups, including the Pittsburgh Poles, typically first built fraternal societies and then churches. The fraternal societies laid the foundation for lasting communities and helped preserve ethnic unity and Polish culture for the immigrants and their children. The organizations also provided insurance programs for their members along with donating large sums of money to humanitarian, social, educational, religious, and cultural programs. Additionally, these societies also played a part in reviving the Polish state in Europe.

The first Polish society in the United States, the Society of Poles in America, was organized in New York City in 1843. By 1880, there were 11 Polish organizations throughout the country. These original societies all had the same general goals: to provide aid, shelter, and protection for new arrivals from the Old Country. Additionally, they focused on preserving Polish traditions and culture among the new Polish Americans.

The first Polish mutual aid society in Pittsburgh was the St. Stanislaus Aid Society, which was established in June 1873.

The Polish National Alliance (PNA) is the largest fraternal society of Americans of Polish descent. It was founded and based in Chicago in 1880 but had organizational roots in Philadelphia. Seventeen fraternal organizations joined the alliance, including five from Pennsylvania. The PNA believed that the organization could both help preserve Polish history and culture in the United States as well as mobilize American Poles to assist in the rebirth of Poland in Europe. At one point, the PNA maintained operations in 36 states and included more than 1,400 lodges.

A major achievement of the PNA in preserving Polish culture was the establishment of Alliance College in Cambridge Springs, Pennsylvania, in 1912. Cambridge Springs is about 100 miles north of Pittsburgh. The college had originally been established to educate Polish Americans and preserve their historical and cultural heritage. It offered courses in Polish language and literature as well as majors in a variety of disciplines. Suffering from declining enrollment, the college closed in 1987.

A major rival of the Polish National Alliance was the Polish Roman Catholic Union of America (PRCU). The PRCU was founded in Chicago in 1873 by Rev. Theodore Gieryk, a former chaplain in the Prussian army. Nationally, the PRCU had 175,000 members in the mid-1950s. In contrast with the PNA, the PRCU defined membership in the Polish community as including membership in the Roman Catholic Church. PRCU leaders did not emphasize regaining Polish independence to the same extent as the PNA. The PRCU instructed its members that their primary duties were to preserve Polish culture and the Catholic faith. The St. Casmir Society, local chapter of the PRCU, was organized in 1904, and by 1936 occupied property at 227 Forty-Third Street in Lawrenceville.

The Polish Falcons were originally established in Poland in 1867, four years after an unsuccessful uprising against Czarist Russia. It was founded as a paramilitary organization devoted to preparing its members to fight for Polish independence. In America, the Falcons were established as a national fraternal and physical fitness organization that sought to preserve the Polish language and culture through educational and social programs. The first Falcon nest in America was organized in Chicago in 1887.

The St. Joseph Union was established in Pittsburgh by a group of Catholic men from Pittsburgh's Polish Hill in 1890. This was a fraternal and beneficial society intended for mutual aid and assistance of widows and orphans of deceased members.

The Society of Our Lady of Czestochowa (SOLOC) was formed in 1900 in Lawrenceville. Its purpose was to promote mutual aid to its members in case of illness or misfortune. For years, the organization operated a club called the SOLOC Home in a former mansion at 401 Forty-Second Street.

The Polish Army Veterans Association was housed in a building at the corner of Fisk and Butler Streets in Lawrenceville. This organization was open to any person who served in the Polish military, including those who served during World War I.

The Polish Women's Alliance of America (Zwiazek Polek) was founded in Chicago in 1898. One of the chief motivations for establishment of this society was the fact that at that time, the major Polish American fraternal societies would not let women join. A stated purpose of this society is "To protect the honor and rights of Polish womanhood and endeavor to preserve national esteem." Pittsburgh played a key role in the early days of this organization.

The Central Council of Polish Organizations of Pittsburgh was established in 1930 when 11 Polish associations banded together to facilitate interaction among the groups and better represent their common interests.

The Central Council of Polish Organizations became the Polish Cultural Council in 2001. It is currently very active in preserving Polish heritage in Pittsburgh. Its mission is to coordinate the activities of dozens of Polish cultural and fraternal groups in the Pittsburgh area.

The Polish Arts League was founded in Pittsburgh in 1948. Similar organizations had existed for years in Chicago, Detroit, Buffalo, Newark, and Youngstown. The goals of the Polish Arts League include making Polish art, music, and literature better known throughout the United States and providing aid to promising Polish and American writers, musicians, and artists.

The Polish American Congress (PAC) was formed in 1944 by Polish Americans concerned about the treatment of Poland by the Allies after World War II, and by the takeover of Poland by the communists. The PAC is a political association, representing Polish organizations across the United States. It has lobbied the US president and Congress on all matters Polish. The PAC is recognized by the Republic of Poland and the US government as the voice of Polonia in the United States and is regularly consulted by the US State Department.

The Kosciuszko Foundation was organized in 1925. Its headquarters are in New York, but it maintains eight regional chapters throughout the United States, including one in Pittsburgh. The goal of the foundation is to promote educational and cultural exchanges between the United States and Poland and to increase American understanding of Polish culture and history.

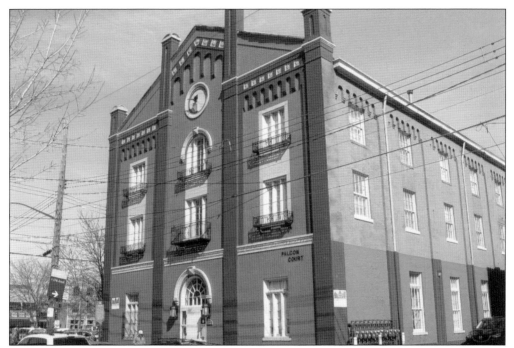

POLISH FALCONS OF AMERICA NATIONAL HEADQUARTERS. This building on Eighteenth Street on Pittsburgh's South Side originally housed Nest 8 and the national headquarters for the Polish Falcons of America in 1912 and for many years after. It is now an apartment building named Falcon Court. In 1909, Nest 176 of the Polish Falcons was organized in the Strip District and held its meetings at Klein Hall at 2813 Penn Avenue. On Polish Hill, the Polish Falcons and the Polish Lyceum occupied the abandoned buildings of the Western Medical College. (Rudiak family.)

CURRENT POLISH FALCONS (NEST 8) ON EIGHTEENTH STREET. This building is located on the South Side, several blocks from the original building pictured above. (Stanley States.)

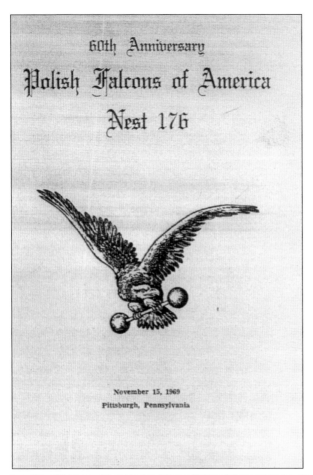

60th Anniversary

Polish Falcons of America

Nest 176

November 15, 1969
Pittsburgh, Pennsylvania

PROGRAM FOR POLISH FALCONS ANNIVERSARY. Seen here is a printed program for the 60th anniversary of Polish Falcons Nest 176 in 1969. The Polish Falcons and the Polish National Alliance were the two most influential Polish fraternal organizations in the United States. (Carnegie Library of Pittsburgh.)

POLISH WOMEN'S ALLIANCE BAND. The Polish Women's Alliance all-girl band poses on the steps of Immaculate Heart of Mary Church on Polish Hill with pastor Fr. Joseph Sonnefeld in the 1940s. One of the first branches of the Polish Women's Alliance was formed in Braddock near Pittsburgh in 1908 at a time when all of the other branches were in Chicago. (Immaculate Heart of Mary Church.)

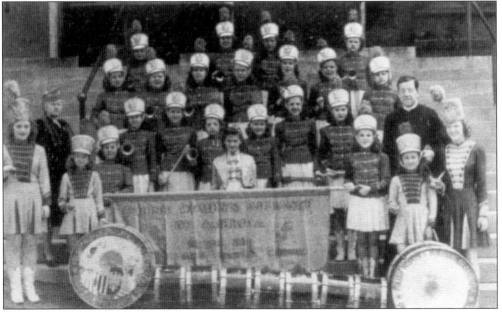

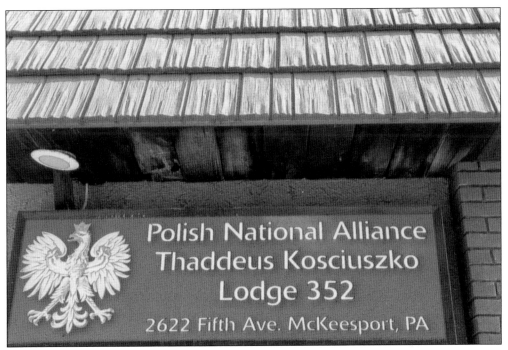

PNA Lodge. This current Polish National Alliance Lodge is located in McKeesport, just outside of Pittsburgh. The PNA is the largest Polish fraternal society in the United States. In 1975, there were 2,500 active members in Pittsburgh. (Stanley States.)

Program for PNA District Anniversary. Seen here is the published program for the 75th anniversary of PNA District VIII in 1955. The largest branch of the PNA in the Pittsburgh region was the Radiant Society, which was formed in the Strip District in 1893. The Radiant Society purchased a headquarters building in the 400 block of Plummer Street in Lawrenceville in 1906. In the early 1970s, the lodge moved to the 6200 block of Butler Street, where it continued to operate as a social club until the late 1980s. There are still several active PNA branches in the Western Pennsylvania area. (Carnegie Library of Pittsburgh.)

75-TH ANNIVERSARY
OF THE
POLISH NATIONAL ALLIANCE

Z.N.P.

HELD BY
DISTRICT VIII P.N.A.
Sunday, May 15, 1955
Hotel William Penn
Pittsburgh, Pennsylvania

PNA SUMMER PROGRAM. This is a group photograph of summer students at the Polish National Alliance summer program held at Alliance College in Cambridge Springs in 1967. For many years, the Alliance College, under the auspices of the PNA, offered summer programs for high school and college students to study Polish language, music, and dance. Many students from the Pittsburgh area participated in this program. (Lane family.)

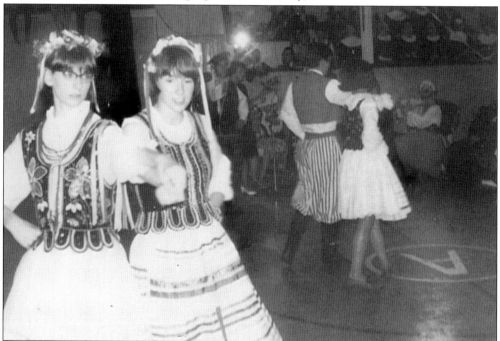

PNA SUMMER PROGRAM DANCING PERFORMANCE. This dancing performance was presented by summer students attending the PNA summer program held at Alliance College in Cambridge Springs in 1967. The dancers in the foreground are Marcia Pilkiewicz (left, from Warren, Michigan) and Arlene Kuzdzal (from Dearborn, Michigan). (Lane family.)

ANOTHER VIEW OF **PNA** SUMMER PROGRAM DANCING PERFORMANCE. Here is another view of the dancing performance by summer students at the Polish National Alliance summer program held at Alliance College in Cambridge Springs in 1967. (Lane family.)

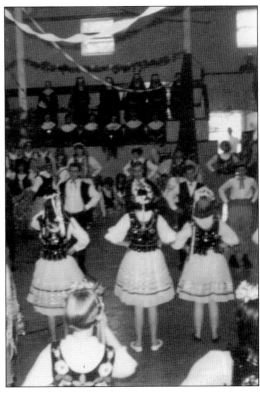

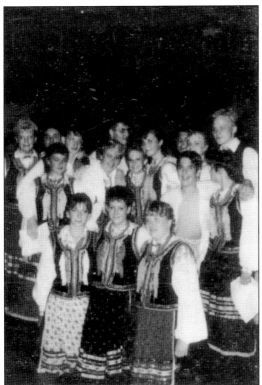

PNA SUMMER PROGRAM. A group of summer students pose at the PNA summer program at Alliance College in 1985. The student at center in the first row is Michelle Rodabaugh of Pittsburgh. (Stanley States.)

CATHEDRAL OF LEARNING. Seen here is the University of Pittsburgh's Cathedral of Learning Commons Room. The Polish Arts League held its meetings in this iconic building for years. (University of Pittsburgh.)

POLISH ROOM. The Polish Room, constructed in 1938–1940, is located in the Cathedral of Learning. The decor is based on the early 16th century Polish Renaissance, which was the golden age in Poland's history. The ceiling, garland, great table, and windows of the room were inspired by Wawel Castle in Krakow, Poland. The portrait of Copernicus shows him studying the heavens from the roof of his uncle's home. In the bay window stands an enlarged replica of the Jagellonian globe, depicting North America as a separate continent. Seals of famous Polish universities and technical schools appear in the windows. (University of Pittsburgh.)

Five

CHURCHES, SYNAGOGUES, SCHOOLS, AND AN ORPHANAGE

Important aspects of the lives of immigrant Pittsburgh Poles were where they worshiped, how they educated their young, and how they took care of their children in need. The church and the synagogue were at the center of the ethnic community. They protected the family, preserved the language, and educated the children. These religious institutions also provided a variety of social functions ranging from raising and distributing charitable funds to organizing events like picnics and festivals.

To a large extent, Polish identity and culture have been intertwined with Polish Roman Catholic parishes.

In 1873, the St. Stanislaus Beneficial Society organized the first Polish parish in Pittsburgh. It purchased the old Presbyterian church on Fifteenth Street and Penn Avenue in the Strip District, which was subsequently dedicated as St. Stanislaus Kostka Church.

St. Stanislaus is referred to as the "mother church of all Western Pennsylvania Polish parishes." In 1891, the parish purchased a lot on Twenty-First and Smallman Streets and constructed a new Romanesque-style church. They also constructed a new school to accommodate 900 students. The church and school are located at the end of Pittsburgh's historic Produce Terminal, which runs for seven city blocks on Smallman Street.

St. Adalbert Church, located at South Fifteenth Street on the South Side, is the second oldest Polish parish in Pittsburgh. In 1884, the church committee bought a lot between Fifteenth and Sixteenth Streets for construction of a church.

Originally, the settlers living on Polish Hill belonged to St. Stanislaus Kostka Parish in the Strip District. However, travel to St. Stanislaus was difficult and a little dangerous due to the need to cross the Pennsylvania Railroad tracks and two sets of streetcar tracks. In 1895, members of the St. Francis Xavier Society petitioned Bishop Phelan of the Pittsburgh Diocese for a church and school to be built on Polish Hill. The Immaculate Heart of Mary chapel, school, and convents on Paulowna Street were completed in September 1897. Church services were conducted on the upper floor. Below, there were 10 rooms designated for school use. In July 1904, the cornerstone was blessed for a new church and rectory on Brereton Avenue. The parish grew from 493 families in 1896 to 1,000 families in 1945. The Immaculate Heart of Mary remains as a Polish ethnic parish today.

Over the years, several other Polish parishes were built in Pittsburgh, including St. Josephat on Mission Street on the South Side (1902), Holy Family on Forty-First and Foster Streets in Lawrenceville (1904, and later on Forty-Fourth Street), Guardian Angels on Steuben Street in the

West End (1911), St. Hyacinth on Craft Avenue in Oakland (1916), and St. Cyprian on Stockton Avenue on the North Side (1920).

By 1932, there were eight Polish Roman Catholic parishes in Pittsburgh. Each operated its own parochial school, with a total of about 10,000 students.

The eight Polish Roman Catholic parishes in Pittsburgh, as well as their schools, have shown a major decline in membership since World War II. Contributing factors include a major relocation of population from the city to the suburbs, marriage outside of traditional ethnic groups, a lack of Polish priests, and the high cost of parochial school tuition. However, the predominant factor is undoubtedly the full assimilation of the descendants of Polish immigrants into mainstream American culture. Over the years, there has been a loss of ethnic unity and identification, which is the eventual consequence of the melting pot that is America.

The Holy Family Orphanage, currently called Holy Family Institute, has served the Pittsburgh area for 110 years. It was founded in 1900 when three orphaned children were brought to the Sisters of Holy Family of Nazareth's (a Polish order of nuns) summer home in Emsworth, located just outside of Pittsburgh, after their Polish immigrant parents died in an accidental fire.

The Polish National Catholic Church was organized in Scranton in 1897. The church was established based on a nationalist concept rather than a religious doctrinal disagreement. The dissent movement originated when the nationalistic Poles clashed with the predominantly Irish and German church hierarchy and insisted on having their own priests and managing their own parishes. Within the Polish National Catholic Church, priests are permitted to marry and there is no fealty to Rome. By 1964, there were 282,000 members in 157 parishes with four bishops and 144 priests throughout the United States.

Two Polish National Catholic churches were established in Pittsburgh, but both of them closed soon after having been established. There were at least nine Polish National Catholic parishes in the area surrounding Pittsburgh—a number of which are still active.

Polish Jews who immigrated to America typically self-identified as Jewish rather than Polish and lived separately from Polish Catholics and Polish Protestants. Polish Jews gathered with fellow Jews from other countries and formed their own vibrant communities.

By the end of the 19th century, 300,000 Jews lived in Warsaw. This was more than in any other city in Europe. A small number of Polish Jews from Warsaw came to Pittsburgh in the 1880s and 1890s. According to an account by one of these immigrants, they worshiped in various synagogues in Pittsburgh. However, because of differences in dialects and variations in rituals, they found it difficult to blend in with these congregations. Therefore, they started conducting services for themselves, and in 1895 organized their own Polish congregation named Shaare Zedeck (Gates of Justice), in Pittsburgh's Hill District. The congregation is still active and currently located in Squirrel Hill.

Although Polish Jews were a significant group during the migration of Jews from Europe to Pittsburgh, the largest ethnic group among Pittsburgh Jews is Lithuanians.

FR. STANISLAUS PARCZYK. Father Parczyk, a priest from the Passionist Order, was the first Roman Catholic priest of Polish descent in the Pittsburgh Diocese. Father Parczyk arrived in Pittsburgh in 1852. Because he spoke German as well as Polish, he was assigned to be the pastor of a German parish in McKeesport, and later at St. Michaels German Parish in Birmingham (now the South Side). By 1852, a number of Poles had settled in Pittsburgh. On November 20 of that year, Father Parczyk celebrated the first Polish mass in the basement of St. Michaels Church on Pious Street. In later years, he was also the pastor of St. Stanislaus Kostka Church in Pittsburgh's Strip District. (St. Stanislaus Kostka Parish.)

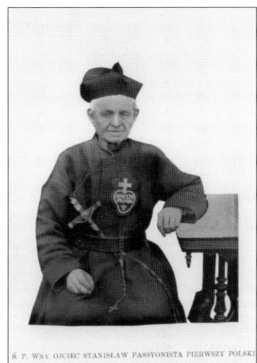

Ś. P. WNY. OJCIEC STANISŁAW PASSYONISTA PIERWSZY POLSKI KAPŁAN W PITTSBURGU, PA.

ŚW. STANISŁAW KOSTKA.

SAINT STANISLAUS KOSTKA. Saint Stanislaus Kostka, for whom St. Stanislaus Church was named, was a bishop of Krakow who was executed by King Boleslaw II on charges of treason. He is remembered in Poland as a symbol of human rights. (St. Stanislaus Kostka Parish.)

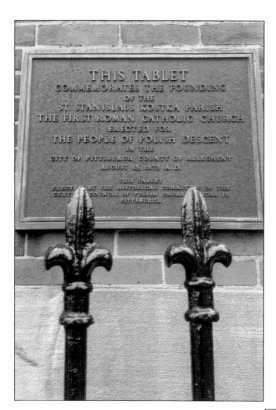

St. Stanislaus Plaque. This plaque commemorates St. Stanislaus Church as the "mother church of all Western Pennsylvania Polish parishes." At the peak of polish immigration, there were 69 Polish Roman Catholic parishes in Western Pennsylvania. (Stanley States.)

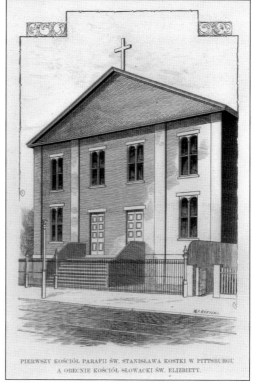

PIERWSZY KOŚCIÓŁ PARAFII ŚW. STANISŁAWA KOSTKI W PITTSBURGU
A OBECNIE KOŚCIÓŁ SŁOWACKI ŚW. ELIZBIETY.

Original St. Stanislaus Church. The first St. Stanislaus Kostka Church was located at Penn Avenue and Fifteenth Street. Lay teachers conducted classes in the basement. Originally, this building had been a Presbyterian church. After the current St. Stanislaus Church was constructed on Twenty-Second and Smallman Streets, this building became the St. Elizabeth Slovak Church. (St. Stanislaus Kostka Parish.)

ST. STANISLAUS CHURCH, 1892. This is
an illustration of the current St. Stanislaus
Church on Twenty-First and Smallman
Streets when it was constructed in 1892.
The church has been through a lot over the
past 125 years. In March 1936, the Saint
Patrick's Day flood caused substantial damage
to the church. The pews were floating in
the church and the sisters were evacuated
from the convent by boat, but the pastor,
Father Sibinski, refused to leave and was
stranded in the rectory. In December 1936,
the Pittsburgh Banana Company warehouse
explosion occurred in close proximity to
the church, and damage was extensive.
Windows were broken, the large crucifix in
the church was destroyed, and the towers,
already weakened by age, were damaged to
the point that they had to be lowered by
40 feet. (St. Stanislaus Kostka Parish.)

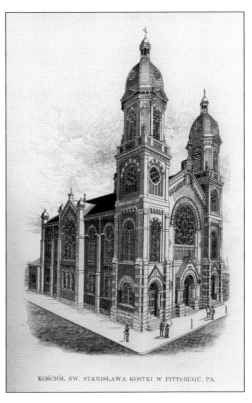

KOŚCIÓŁ ŚW. STANISŁAWA KOSTKI W PITTSBURGU, PA.

SZKOŁA ŚW. STANISŁAWA KOSTKI W PITTSBURGU, PA.

ILLUSTRATION OF ST. STANISLAUS
SCHOOL. The Polish language was a
required course at each of the Polish
Roman Catholic schools in Pittsburgh.
(St. Stanislaus Kostka Parish.)

89

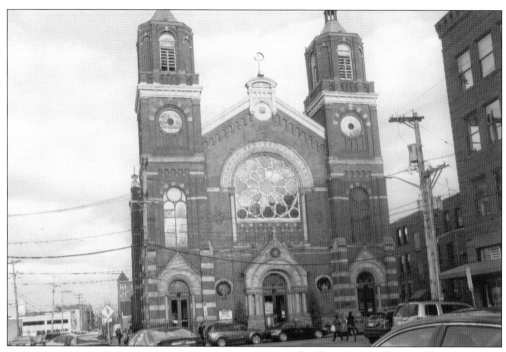

ST. STANISLAUS KOSTKA CHURCH. The St. Stanislaus Kostka Church is located in the Strip District. The ethnic church protected the family, preserved the native language, and educated the children. It welcomed family members into the community at baptism, started new branches of the family through marriage, and escorted them from this life at burial. (Stanley States.)

ST. STANISLAUS ALTAR. Seen here is the altar in St. Stanislaus Kostka Church. Unlike other Pittsburgh parishes, whose congregations have dwindled, St. Stanislaus has experienced a revival over the past decade with a growing population of younger parishioners. This growth is attributed to the resurgence of the Strip District. Additionally, many worshipers still come to this church from the suburbs for sentimental reasons. (Stanley States.)

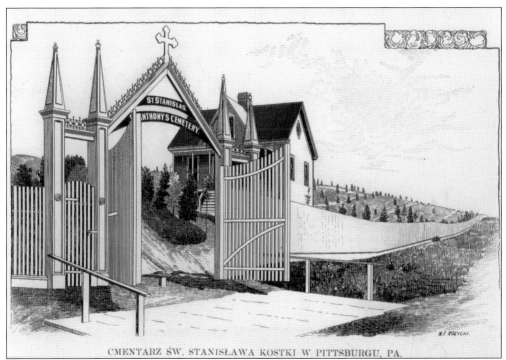

CMENTARZ ŚW. STANISŁAWA KOSTKI W PITTSBURGU, PA.

St. Stanislaus Cemetery. In April 1891, a total of 13 acres of land were purchased in Shaler Township, just north of Pittsburgh, to establish St. Stanislaus Cemetery. Additional land was purchased later to expand the burial grounds. (St. Stanislaus Kostka Parish.)

PAMIĄTKA
SREBRNEGO JUBILEUSZU,
PARAFII ŚW. STANISŁAWA KOSTKI
W PITTSBURGU, PA.
KALENDARZ
NA ROK PAŃSKI 1901.
Historya wszystkich Polskich Rzymsko Katolickich parafii w Dyecezyi Pittsburgskiej.
DRUKIEM WIELKOPOLANINA,
NAKŁADEM PARAFII ŚW. STANISŁAWA KOSTKI,
W PITTSBURGU, PA.

Souvenir Calendar for the St. Stanislaus 25th Anniversary. This is the cover of the 1901 St. Stanislaus parish calendar commemorating the 25th anniversary of the parish. (St. Stanislaus Kostka Parish.)

KS. ZYGMUNT RYDLEWSKI, C. S. SP.
BYŁY ZASTĘPCA PROBOSZCZA W PARAFII ŚW. STANISŁAWA KOSTKI W PITTSBURGU, PA.

FR. ZYGMUNT RYDLEWSKI. Father Rydlewski was in charge of building the Immaculate Heart of Mary Church. He was the assistant pastor of St. Stanislaus Kostka Parish in 1895. At that time, Father Rydlewski was appointed by Bishop Phelan of the Pittsburgh Diocese to head up the project to build the first Immaculate Heart of Mary school, convent, and hall (to be temporarily used as a church) on Polish Hill. Each Catholic family on Polish Hill who owned a house was obliged to donate $50 to the project. Non-homeowning families were asked to contribute $25 to the cause. (Immaculate Heart of Mary Parish.)

ILLUSTRATION OF IMMACULATE HEART OF MARY CHURCH. The current Immaculate Heart of Mary Church was constructed on Brerton Avenue on Polish Hill in 1905. The church was constructed in the Roman Renaissance style and is modeled after the St. Peter Basilica in Rome. The church, perched on the slope of Polish Hill overlooking the Allegheny River Valley, is visible from a large portion of the city. Much of the construction work was performed free of charge by the immigrant parishioners, who worked on the church at night after working all day in the mills. (Immaculate Heart of Mary Parish.)

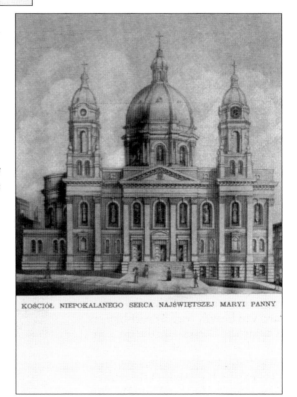

KOŚCIÓŁ NIEPOKALANEGO SERCA NAJŚWIĘTSZEJ MARYI PANNY

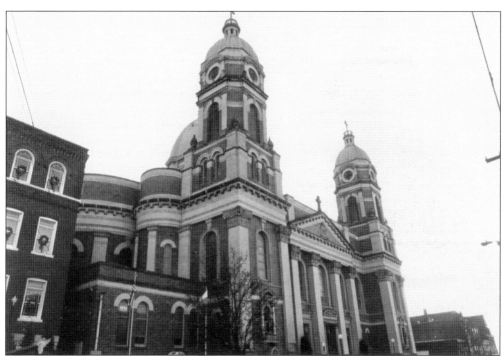

IMMACULATE HEART OF MARY CHURCH.
Historically, fewer than five percent of
Americans who identify as Polish in
the United States claim any religion
but Roman Catholic. These include a
small group of Protestants and members
of the Eastern Orthodox Church.
A small group of Lipka Tartars, who
emigrated from the Bialystok region
of Poland, cofounded the first Muslim
mosque in Brooklyn, New York, in 1907.
(Immaculate Heart of Mary Parish.)

**ALTAR OF IMMACULATE HEART OF
MARY CHURCH.** From 1920 until 1972,
the Immaculate Heart of Mary Parish
operated a lyceum. The building,
which had been the site of the original
University of Pittsburgh Medical School,
contained classrooms, auditoriums,
a gymnasium, and a billiard room
and was heavily used by parishioners.
During the Depression, the Lyceum
served as an entertainment center to
raise funds for flour, milk, coal, and
clothing for the needy of the parish.
(Immaculate Heart of Mary Parish.)

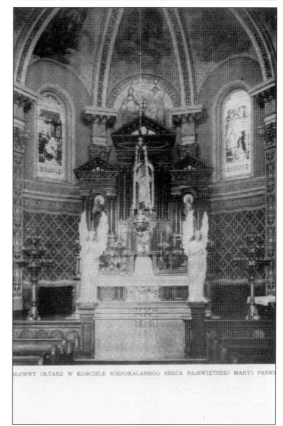

GLOWNY OLTARZ W KOSCIELE NIEPOKALANEGO SERCA NAJSWIETSZEJ MARYI PANNY

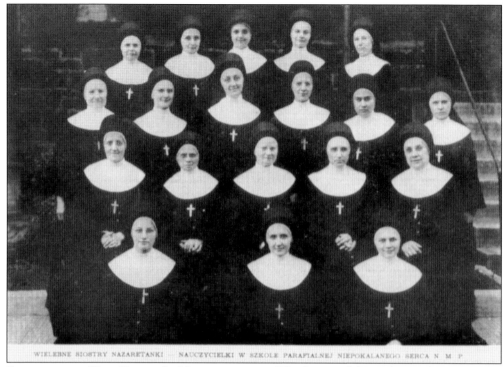

WIELEBNE SIOSTRY NAZARETANKI NAUCZYCIELKI W SZKOLE PARAFIALNEJ NIEPOKALANEGO SERCA N M P

SISTERS OF THE HOLY FAMILY OF NAZARETH, 1947. The Sisters of the Holy Family of Nazareth Congregation, a Polish order, taught at the Immaculate Heart of Mary School. Eight nuns from this order began teaching at the school in 1897. Originally, all instruction and prayers in the school were in Polish. (Immaculate Heart of Mary Parish.)

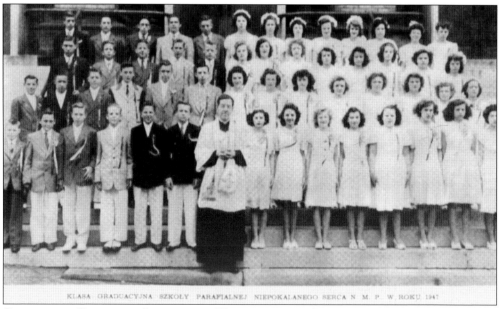

KLASA GRADUACYJNA SZKOLY PARAFIALNEJ NIEPOKALANEGO SERCA N M P W ROKU 1947

GRADUATING CLASS FROM IMMACULATE HEART OF MARY GRADE SCHOOL, 1947. At its peak, the school served 2,000 students. The parish school closed in 1997. (Immaculate Heart of Mary Parish.)

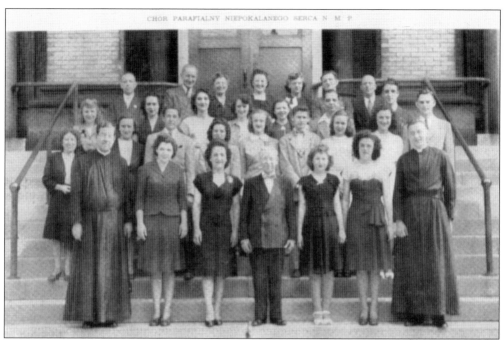

CHÓR PARAFIALNY NIEPOKALANEGO SERCA N M P

IMMACULATE HEART OF MARY CHURCH CHOIR. Members of the choir pose with the parish priests on the front steps of the church in 1947. (Immaculate Heart of Mary Parish.)

IMMACULATE HEART OF MARY SOUVENIR ALBUM. The Immaculate Heart of Mary Parish put together a souvenir album commemorating the parish's 50th anniversary in 1947. (Immaculate Heart of Mary Parish.)

1897

Album Pamiątkowy

Złotego Jubileuszu

Parafii Niepokalanego Serca

Najświętszej Maryi Panny

w Pittsburghu, Pennsylvania

w niedzielę, 24-go sierpnia

1947

PROGRAM

GOLDEN JUBILEE BANQUET

of the

Immaculate Heart of Mary Church

at West Penn Park Auditorium

Sunday, August 24th, 1947

at 6:00 P. M.

✦ ✦ ✦

OPENING ADDRESS Mr. Peter Chuderewicz
Chairman, Jubilee Executive Committee

NATIONAL ANTHEMS Miss Jane Dobrosielski
Star Spangled Banner
Jeszcze Polska nie Zginęła

INVOCATION Very Rev. Father Justyn Figas, O. M. C.
Buffalo, N. Y.

TOASTMASTER Mr. Charles Lawniczak

SONG — "Witamy" (Welcome) St. Cecelia Choir

ADDRESS Hon. John J. Kane
Chairman of County Commissioners, Allegheny County

ADDRESS Dr. Wm. D. McClelland
Coroner, Allegheny County

ADDRESS Mr. Albert Harenski

DUET Miss A. Mileszko and Miss V. Szczepanska
Accompanied by Mr. Alphonse Mileszko

ADDRESS Mr. Merle Czajkowski

ADDRESS Hon. Benjamin Lencher
Judge, County Court of Allegheny County

ADDRESS Mr. Jacob Szalinski

SOLO — "Ave Maria" Miss Jane Dobrosielski

ADDRESS S. F. Dobrowolski, Esq.

RECITATION Joseph Szurszewski
of Immaculate Heart of Mary Parochial School

ADDRESS Hon. Artemas C. Leslie
District Attorney of Allegheny County

RECITATION Marianna Pawlak
of Immaculate Heart of Mary Parochial School

ADDRESS Rev. Father Joseph Sonnefeld, C.S.Sp.
Pastor, Immaculate Heart of Mary Church

INTRODUCTION OF ORGANIZATIONS Mr. Charles Lawniczak

"BOŻE COS POLSKĘ" St. Cecelia Choir

✦ ✦ ✦

DANCING WILL FOLLOW DINNER PROGRAM

Music by

POLISH ARISTOCRATS ORCHESTRA

GOLDEN JUBILEE BANQUET FOR THE IMMACULATE HEART OF MARY PARISH. The Immaculate Heart of Mary Parish celebrated the 50th anniversary of the parish in 1947. This is a copy of the program for the Golden Jubilee Banquet. A number of prominent local government officials spoke at this celebration. (Immaculate Heart of Mary Parish.)

IMMACULATE HEART OF MARY FIRST COMMUNION CLASS, 1957. The 1957 First Holy Communion Class at Immaculate Heart of Mary Church is seen here. Henry Goliat is in the first row, sixth from the right. The priest is Fr. Stanley Grondziowski. (Goliat family.)

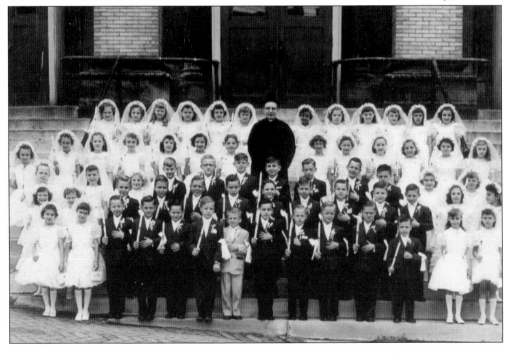

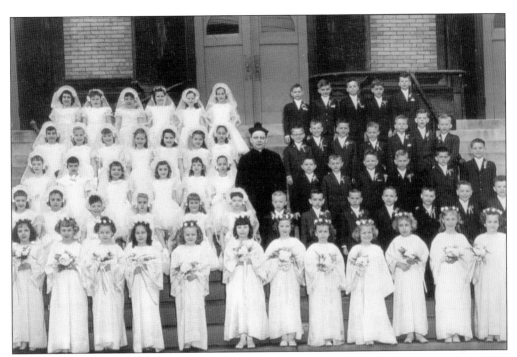

IMMACULATE HEART OF MARY
FIRST COMMUNION CLASS,
1961. Pictured here is the
1961 First Holy Communion
Class at Immaculate Heart of
Mary Church. Frances Goliat
is in the third row, third from
the left. The priest is Father
Grondziowski. (Goliat family.)

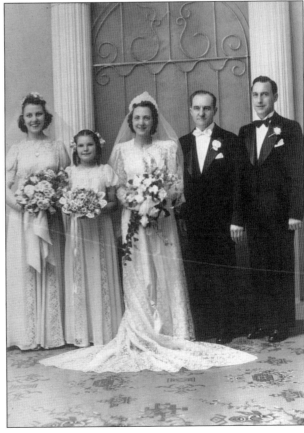

JANUSZEWSKI WEDDING. The 1939
wedding of Frank Januszewski and
Josephine Kruszewski took place
in Holy Family Church on Forty-
Fourth Street in Lawrenceville.
The original Holy Family Church
and School were constructed
on Forty-First and Butler Streets
in 1904. By the time the parish
celebrated its silver anniversary
in 1928, Holy Family included
1,050 families, and more than
1,000 children were attending
the school. (Lisowski family.)

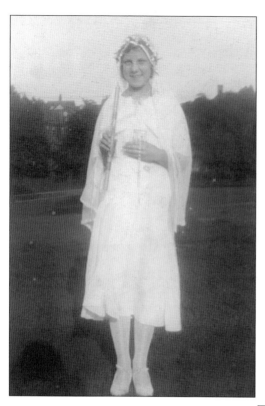

HARRIET KRUSZEWSKI CONFIRMATION.
Harriet Kruszewski's Confirmation
took place in Holy Family Church
in 1930. (Lisowski family.)

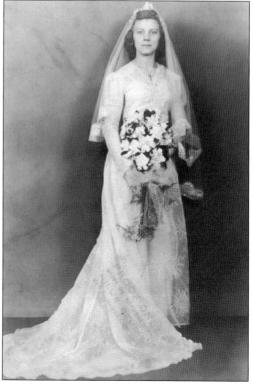

**BRIDE HARRIET KRUSZEWSKI IN HOLY FAMILY
CHURCH.** Harriet Kruszewski is pictured at
her wedding to Anthony Lisowski in 1942
at Holy Family Church on Forty-Fourth
Street in Lawrenceville. A new Holy Family
Church was built on Forty-Fourth Street in
1940. A new school, rectory, and convent
were constructed in 1964. (Lisowski family.)

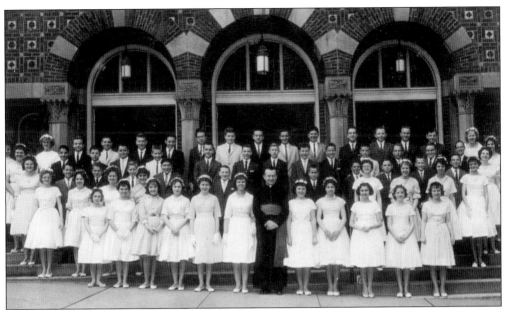

HOLY FAMILY SCHOOL'S EIGHTH-GRADE CLASS, 1960. Marilyn Lisowski is in the second row, third from right. In 1975, there were approximately 800 Polish churches with 600 parish schools throughout the United States. (Lisowski family.)

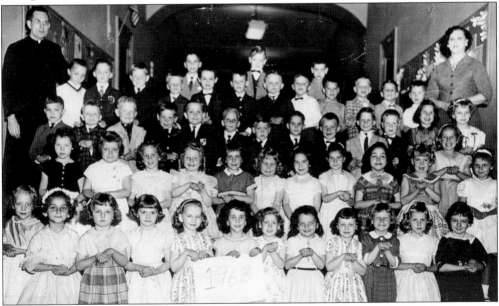

KINDERGARTEN CLASS AT HOLY FAMILY SCHOOL, 1963. Pictured here is the 1963 kindergarten class at Holy Family School at Forty-First and Foster Streets in Lawrenceville. Fr. Stanley Jozwiak is the parish priest at upper left, Regina Kaminski is the teacher at upper right, and Jude Wudarczyk is the second boy to her left. While the Polish churches were an important part of ethnic life in Polish neighborhoods, the church-affiliated schools were also centers of activities. Scouting troops and athletic teams helped maintain community identity. Inter-neighborhood competition was intense, and the parish school teams received strong support from adults in the community. (Wudarczyk family.)

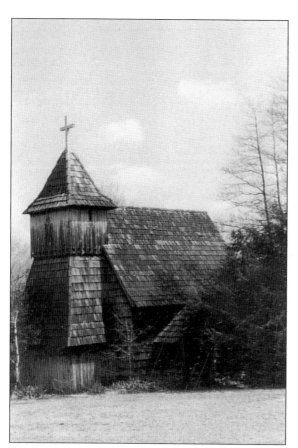

PAULINE FATHERS' CHAPEL IN KITTANING. Seen here is the chapel built by Boy Scouts at Pauline Fathers' Monastery in Kittaning outside of Pittsburgh. This photograph of the Polish monastery was taken in 1990. (Kozlowski family.)

ST. CYPRIAN ALTAR BOYS, 1935. St. Cyprian Parish was established on the North Side in 1920. The original church and school were located on Stockton Avenue. As a result of extensive renovation of the North Side in the 1950s and 1960s, the church and school were razed at that time. In 1964, St. Cyprian Church merged with Mary Immaculate Church (Italian) located at Middle and Suismon Streets on the eastern end of the North Side. (Konefal family.)

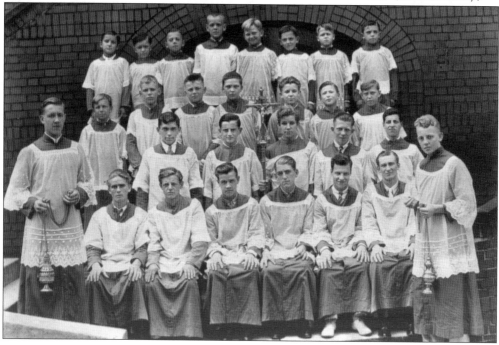

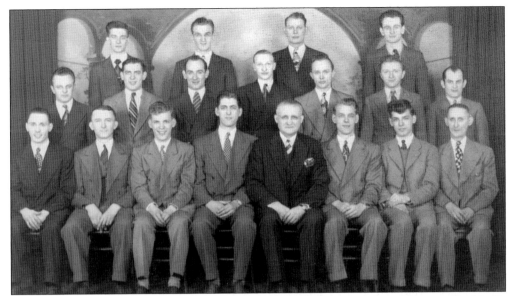

St. Cyprian Church Choir. The St. Cyprian Church Choir is pictured here on the North Side in 1948. Identified are Professor Przanowski (first row, center), Stan and Ted Konefal (sitting on the professor's right side), Charlie and Ray Konefal (sitting on the professor's left side), Joe Baranowski (second row, second from left), and Walt Szutzman (third row, second from left). (Konefal family.)

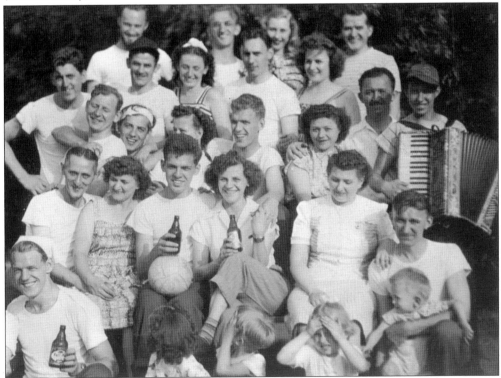

St. Cyprian Church Choir Picnic. This is the St. Cyprian choir picnic on the North Side in the 1950s. (Konefal family.)

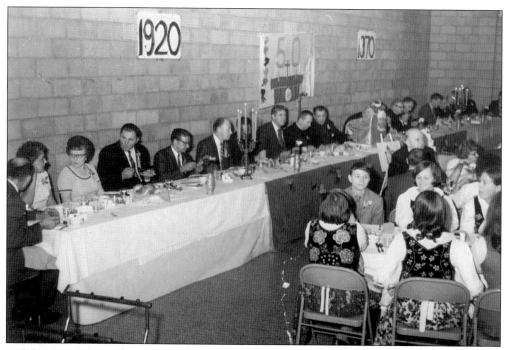

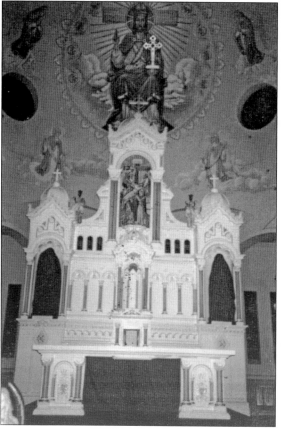

St. Cyprian Parish 50th Anniversary. St. Cyprian Parish celebrated its 50th anniversary on the North Side in 1970. Seated at the center of the banquet table is Stanley Konefal, master of ceremonies. Two seats to his left is Fr. Gabriel Brezinski, pastor of the parish. (Konefal family.)

St. Josephat Church. St. Josephat Church is located on Mission Street on the South Side. The original wooden church was built in 1902. It was replaced by a larger church in 1916. (Carnegie Library of Pittsburgh.)

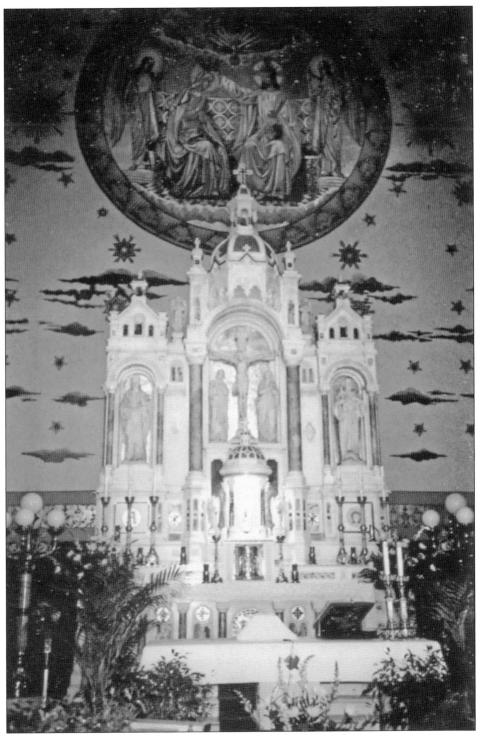

St. Adalbert Church. Both St. Josephat and St. Adalbert Churches were part of a merger of four Catholic parishes on the South Side in the late 1990s, which formed Prince of Peace Parish. (Carnegie Library of Pittsburgh.)

CHILDREN PLAYING AT HOLY FAMILY INSTITUTE. Fr. Cezry Tomaszewski is credited with initiating the organization of the Holy Family Orphanage. (Carnegie Library of Pittsburgh.)

SISTER COMBING A CHILD'S HAIR. The orphanage was originally founded in 1900. In 1904, the home was formally named the Orphan Asylum of the Holy Family. (Carnegie Library of Pittsburgh.)

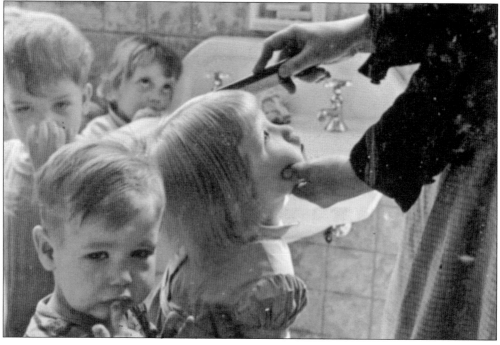

CHILDREN IN CLASS. The mission of the institution gradually evolved from a true orphanage to a small group-living facility serving both orphans and other children in need. Due to the evolved mission, the organization's name changed from Orphan Asylum of the Holy Family to Holy Family Institute in 1931. (Carnegie Library of Pittsburgh.)

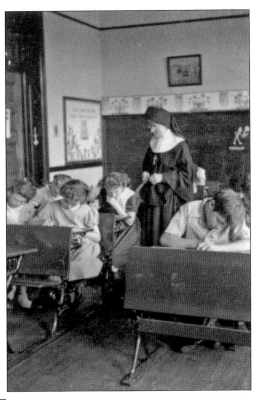

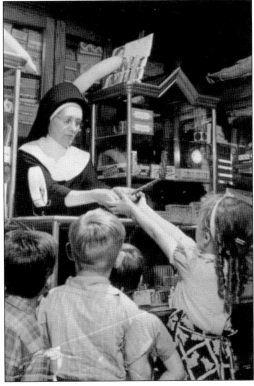

SISTER HANDING OUT SUPPLIES. In 1946, a total of 45 Polish war refugee children found sanctuary at Holy Family. (Carnegie Library of Pittsburgh.)

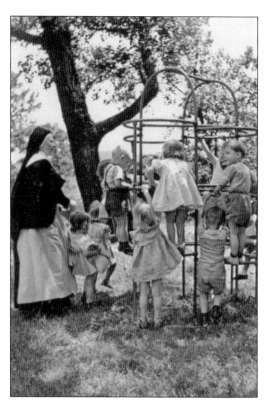

CHILDREN ON THE PLAYGROUND. Today, the majority of the institute's services include educating behaviorally challenged children, counseling, helping families to function as a unit, drug and alcohol counseling, and outpatient mental health counseling. (Carnegie Library of Pittsburgh.)

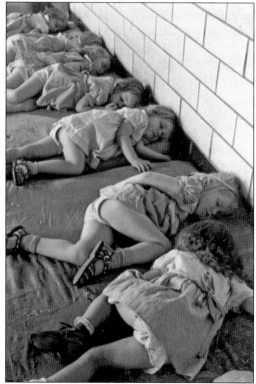

LITTLE GIRLS TAKING A NAP. The congregation of nuns that founded the Orphan Asylum of the Holy Family are the Sisters of the Holy Family of Nazareth. (Carnegie Library of Pittsburgh.)

LITTLE GIRL WITH DENTIST. The Sisters of the Holy Family of Nazareth Congregation was originally founded in Rome in 1875 by Frances Siedliska, a Polish noblewoman. Ten years after the founding of the order in Rome, the founder and 11 nuns set out for Chicago, where they ministered to the needs of Polish immigrant children and families. (Carnegie Library of Pittsburgh.)

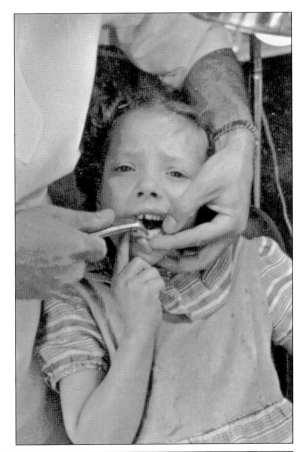

THE SCHOOL BAND. The current executive director of Holy Family Institute is Sr. Linda Yankoski. (Carnegie Library of Pittsburgh.)

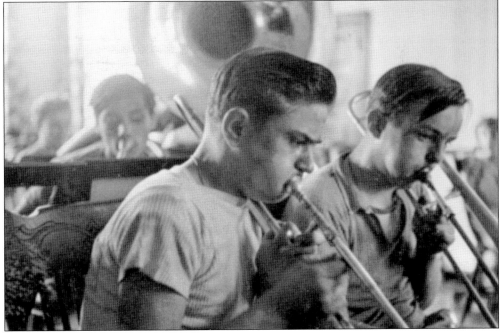

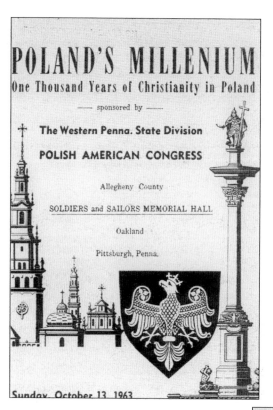

POLAND'S MILLENNIUM. Seen here is the program for a 1963 ceremony at Soldiers & Sailors Hall celebrating the 1,000th birthday of Poland and 1,000 years of Christianity in Poland. At another celebration, more than 18,000 people gathered at the Pittsburgh Civic Arena in 1961 to commemorate the millennium of Christianity in Poland. (Carnegie Library of Pittsburgh.)

POPE JOHN PAUL II. When Pope John Paul II, the Polish pope, visited Philadelphia in October 1979, two busloads of parishioners from the Immaculate Heart of Mary Church on Polish Hill were led by their pastor, Fr. John Jendzura, to witness the event. The bus riders' banner read, "*Ojcie Swiety Zyczemi Tobie Zdrowia, Szczescia, I Dlugich Latzycia*" ("Holy Father, Wishing You Health, Happiness, and Longevity"). The pilgrims sang secular songs, Polish hymns, and folk songs during the ride. They also prayed the rosary in both Polish and English. (Stanley States.)

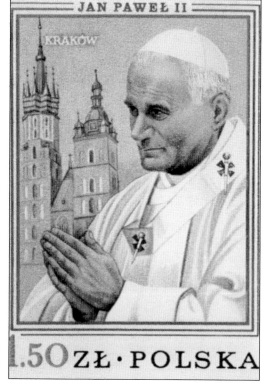

YOUNG ISRAEL OF PITTSBURGH–SHAARE ZEDECK CONGREGATION. The Shaare Zedeck Jewish congregation was originally founded in Pittsburgh in 1895 by Polish Jews. The congregation was first established on Scott Street in Pittsburgh's Hill District. In 1974, it merged with the Young Israel Congregation and moved to its present location on Bartlett Street in Squirrel Hill. (Stanley States.)

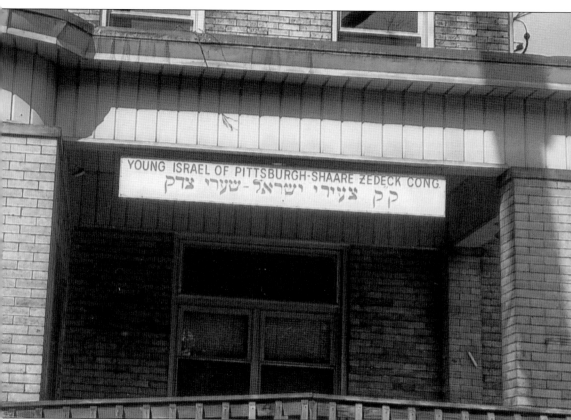

YOUNG ISRAEL OF PITTSBURGH–SHAARE ZEDECK CONGREGATION. As was the case for Christian Polish immigrants, Jewish ethnic societies helped to provide a social life for newcomers to Pittsburgh. In 1904, Pittsburgh Polish Jews obtained a charter for the Ershte Warshawer Untershtitzung Verein (First Warsaw Support Group). One of the members recounted, "Sundays were heaven. We had picnics every Sunday at the Polish Shule (synagogue). Every month a different member would contribute herring and a sack of potatoes. The women prepared the herring and potatoes and we always had a meal ready for anyone who was hungry." (Stanley States.)

Six

Newspapers and Other Periodicals

The Pittsburgh Polish had a number of Polish-language newspapers and periodicals. These publications provided Polish Americans with news from the Old Country as well as happenings in their own communities. They were a strong force in preserving the Polish heritage among the immigrants and their descendants. They also helped immigrants adapt to the American way of life. Many of these newspapers eventually became bilingual or entirely English-language. The following are some of the important Polish periodicals that were popular in the Pittsburgh area:

Wielkopalanin was established as a weekly newspaper in 1899 by Fr. Cezary Tomaszewski.

Narod Polski (*Polish People*) is the official semi-monthly publication of the Polish Roman Catholic Union of America (PRCU).

The *Gazeta Pittsbugska* informed Pittsburgh Poles of national and international news and reported on events occurring in the Polish homeland. It also devoted attention to items of interest within the local Polish neighborhood communities.

Pittsburczanin (*Pittsburgher*), founded by Victo L. Alski, was a Polish newspaper that was first published in 1920 and remained in print until 1976. The publication was originally printed daily and was based in Lawrenceville. The publisher of the *Pittsburczanin* resisted the trend among other ethnic periodicals to print an English edition or at least a portion of the periodical in English. The fact that the *Pittsburczanin* was always published exclusively in Polish is believed to have hastened the paper's eventual demise.

Sokol Polski (*Polish Falcon*) is the periodical still published by the Polish Falcons. Since 2013, the Polish Falcons have also produced an internet periodical named *Sokol Online*.

Zgoda (*Unity* or *Harmony*) is the official newspaper of the Polish National Alliance. The periodical was first published in 1881 through the efforts of Frank Gryglaszewski, later a censor of the PNA, and remains in publication today. It is a Polish newspaper that was not started in Pennsylvania, but had a dedicated readership in this state and throughout the nation. *Zgoda* contains articles and photographs concerning the national organization and the lodges across the United States. It informs PNA members about all matters of interest to Polish Americans. In Chicago, the PNA still publishes a daily newspaper named *Dziennik Zwiaskowy* (*Polish Daily News*). It is published Monday through Thursday with a special weekend edition and has been published without a break since 1908. The PNA also sponsors its own radio station in Chicago, WPNA.

Glos Polek (*Polish Women's Voice*) was the monthly newspaper published by the Polish Women's Alliance.

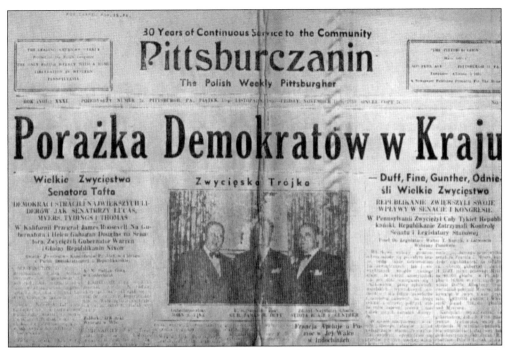

PITTSBURCZANIN. Seen here is a 1950 edition of *Pittsburczanin*, a newspaper published in Lawrenceville and only in Polish. (University of Pittsburgh Library.)

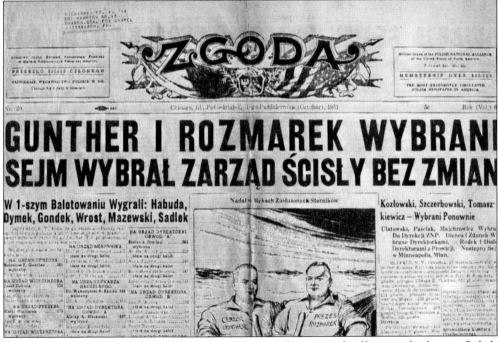

ZGODA. *Zgoda* is the official publication of the Polish National Alliance, the largest Polish fraternal organization in the United States. This is an edition that was printed in Polish in 1951. (University of Pittsburgh Library.)

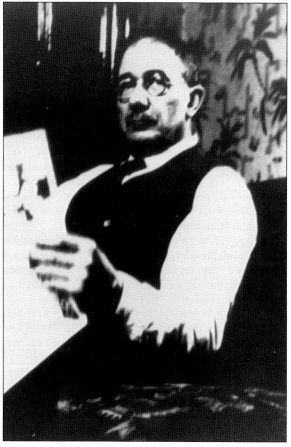

SOKÓŁ POLSKI. *Sokol Polski* is the official publication of the Polish Falcons. This is an issue printed in 2011. (University of Pittsburgh Library.)

MAN READING NEWSPAPER. Joseph Statkiewicz reads a Polish newspaper in 1932. Since Statkiewicz emigrated from Poland and finally settled in Pittsburgh in 1911 at 39 years old, his command of the Polish language was always much better than that of English. Therefore, he and other Polish immigrants relied on periodicals written in Polish for most of their news about Pittsburgh, the United States, and the Old Country. (Stanley States.)

Seven

PITTSBURGH POLES AND THE STRUGGLE FOR AN INDEPENDENT POLAND

The Pittsburgh Polish community was a leader in the struggle to restore an independent Poland.

World War I provided Poles everywhere with the hope of restoring Polish independence. As the war dragged on and Germany, the Austro-Hungarian Empire, and Russia became exhausted, Polish organizations in Europe and the United States petitioned the governments of England, France, and the United States to support reestablishment of a Polish state.

A major step in this direction was the formation of a Polish American army to fight along with the Polish army and the Allies in Europe. In September 1917, President Wilson issued a statement to the effect that those who did not fall into the category of potential recruitment into the US forces might be recruited into the Polish army. It was decided that France would officially sponsor the formation of the Polish fighting force. The Polish American army was created in the United States in an atmosphere of burning patriotism. Polish churches took the lead in recruiting. To them, freedom for Poland was a sacred cause. The first contingent of this army set sail from New York for France near the end of 1917, and other units followed. The farewells were marked by high emotion and patriotic fervor.

The most proactive Polish American organization in the Polish American army movement were the Polish Falcons of America. Under the leadership of Dr. Teofil Starzynski, a Pittsburgh physician, the Falcons worked aggressively to put together a Polish American army.

Dr. Starzynski and a delegation of Polish Falcons visited President Wilson in 1915 to solicit his views concerning the future independence of Poland. President Wilson informed the delegation that "when the United States shall sit at the peace conference all efforts shall be made to see that Poland is free again." This was the first official statement on behalf of Polish independence spoken by a world power since the partition of Poland in 1795.

Five days before the United States declared war, the Falcons met in convention in Pittsburgh to decide what actions to take when the United States declared war on Germany. The Polish pianist Ignacy Paderewski, who later became the first premier of the newly independent Poland, spoke at the convention on April 3, 1917, and proposed a "Kosciusko army" to fight under the Stars and Stripes. He pointed out to the delegates that the future of Poland rested only in their "hands and bayonets." A total of 38,099 American men joined the Polish American army, with 3,000 coming from the Pittsburgh area. About 28,000 of these volunteers made it overseas.

Following the Armistice of November 11, 1918, Polish premier Ignacy Paderewski appeared before President Wilson's close associate "Colonel" Edward Mandell House to plead "the tragic situation of Poland." As a result of this meeting, the Allied diplomats approved the transfer of

the Polish army in France to the new nation of Poland. The army, led by Gen. Joseph Haller, fought the Germans, Ukrainians, and Bolsheviks in the Russian-Polish War (1919–1921). In this confrontation, the Bolsheviks intended to spread their communist ideology in Europe as far as they could through claims of ethnic boundaries. In the *New York Times* on August 16, 2020, President Wilson, realizing how critical the situation was, stated, "The fall of Warsaw and the situation of taking over the Polish Republic threaten civilization and democracy." However, the Bolshevik war minister, Leon Trotsky, claimed "we are bringing liberty and freedom to Western Europe." The fall of Warsaw would have likely resulted in the fall of the newly created Republic of Poland. Fortunately, the Bolsheviks were decisively defeated by the Poles and the Polish American army in the Battle of Warsaw.

On August 17, 1920, in Pittsburgh, 15,000 Polish Americans gathered at a mass meeting near the Point on the Allegheny River, to discuss actions that could be taken by the United States to aid their countrymen who were fighting Bolshevism on the outskirts of Warsaw.

The restoration of the Polish nation was celebrated in Pittsburgh on September 21, 1919, by a parade from the Point to Schenley Park, followed by a ceremony at the entrance to the park. There were 50,000 Western Pennsylvanians of Polish descent who gathered to celebrate Poland's newly found independence. The parade and ceremony were a celebration of the rebirth of the Polish nation but also an expression of gratitude to the United States for its aid in the cause of Poland's liberation.

The Polish American community of Pittsburgh continued to assist in Poland's struggles to survive as an independent nation after World War I. Pittsburgh Poles also responded to Poland's desperate situation following the German and Russian invasions of 1939. They raised funds and donated medical supplies, food, and clothing for the Polish people and refugees.

In 1944, when Russia began to "liberate" eastern Poland, Polish Americans became concerned. The Polish National Alliance Fraternal Society organized a congress of 5,000 delegates, including representatives from the Pittsburgh area, to meet in Buffalo, New York. While the Congress re-pledged its allegiance to the United States, one of its stated goals was to "take a positive stand in matters pertaining to the people of Poland and to assist them in establishing their national independence, civic, religious, and cultural development free from interference of their neighbors." In 1945, the Polish American Congress expressed considerable disappointment with the Yalta Agreement, which permitted Soviet domination of Eastern Europe.

In 1948, the Polish American Congress focused on the Polish displaced persons entering the United States under the Displaced Persons Act of 1948. Judge Blair Gunther of Pittsburgh was elected chairman of the committee to find employment, housing, and transportation for the Polish refugees. More than 12,500 Polish displaced persons were brought to the United States and were supported by a monthly allowance from the Polish American Congress.

The imposition of martial law in Poland in December 1981 touched the hearts of Pittsburgh Poles. Around 300 people, along with city and county elected officials, rallied in Pittsburgh's Market Square on December 30, 1981, to support Poland in this troubled time.

In October 1983, when Polish labor leader Lech Walesa was awarded the Nobel Peace Prize, Fr. John Jendzura offered special thanks during daily mass at the Immaculate Heart of Mary Church on Polish Hill. Father Jendzura stated that Walesa has been fighting for what is right, what is just, for human value, and for the freedom of workers. Polish Americans, through their various organizations like the Polish American Congress, Polish National Alliance, Polish Falcons, and others stood united in their opposition to Soviet domination of Poland and in their support of Lech Walesa and the Solidarity movement.

FR. JOSEPH JAWORSKI. Father Jaworski was one of several Polish American priests from Pittsburgh and the surrounding area who enlisted as chaplains in the Polish American army during World War I. All of these priests were holy ghost fathers. Most of these chaplains served in both France and Poland. (Carnegie Library of Pittsburgh.)

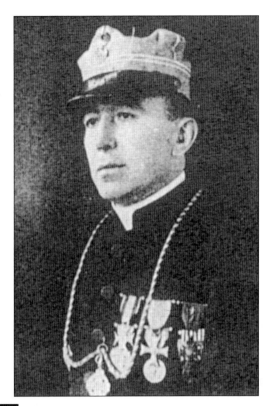

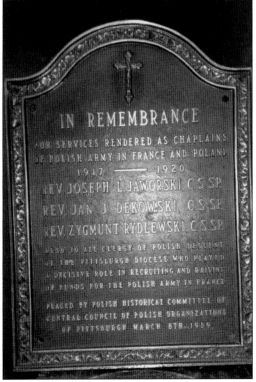

PLAQUE COMMEMORATING POLISH PRIESTS. This plaque commemorates three chaplains who had been priests assigned to the Immaculate Heart of Mary Church on Polish Hill and enlisted in the Polish army, as well as other Pittsburgh clergy who supported the war effort. (Stanley States.)

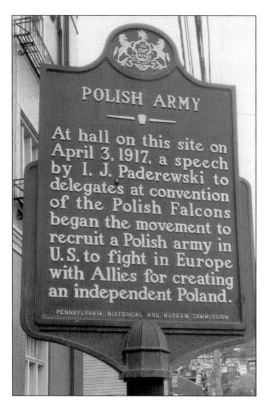

PLAQUE COMMEMORATING IGNACY PADEREWSKI'S SPEECH. Paderewski, at Falcon Hall on Pittsburgh's South Side, delivered a speech encouraging formation of a Polish army to fight in World War I. (Rudiak family.)

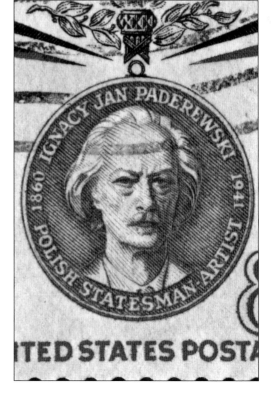

IGNACY PADEREWSKI. Famous Polish pianist and composer Paderewski returned to Poland after World War I to become one of the first premiers of the new republic. Paderewski had first played a concert in Pittsburgh in 1893 at the Old City Hall, formerly located at the corner of Market and Forbes Streets downtown. (Stanley States.)

Dr. Teophil Starzynski. Dr. Starzynski was a Polish physician on Pittsburgh's South Side who served as national president of the Polish Falcons. Dr. Starzynski was very instrumental in organizing training of Polish Americans before the war for eventual service in the Polish army. He also served as a colonel in that army overseas during the war. (Carnegie Library of Pittsburgh.)

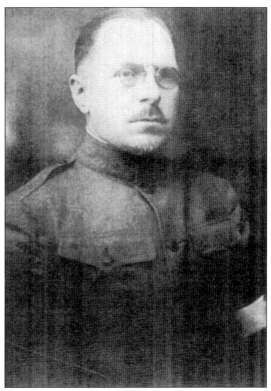

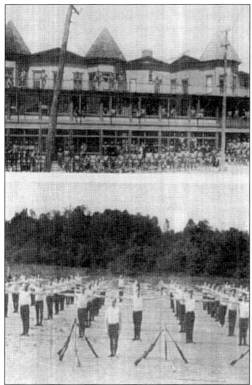

Training at Cambridge Springs. These photographs were taken during Polish Falcon leadership training at the Polish Alliance College in Cambridge Springs in 1914. From May 1913 to June 1914, leadership training courses of two weeks' duration were offered to district groups of Falcons at Alliance College. Each recruit had to provide his own gun and field equipment. (Carnegie Library of Pittsburgh.)

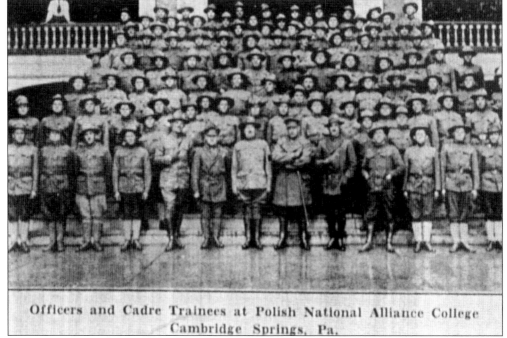

Officers and Cadre Trainees at Polish National Alliance College
Cambridge Springs, Pa.

OFFICER AND CADRE TRAINEES AT CAMBRIDGE SPRINGS. Pictured is an officer and cadre training class at Alliance College in 1914. The first formal field camp for the Pittsburgh Falcons was conducted in February and March 1913 on the grounds of the Holy Family Institute in Emsworth, just outside of Pittsburgh. (Carnegie Library of Pittsburgh.)

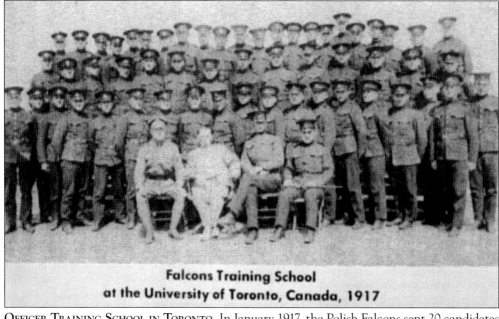

**Falcons Training School
at the University of Toronto, Canada, 1917**

OFFICER TRAINING SCHOOL IN TORONTO. In January 1917, the Polish Falcons sent 20 candidates to Officer Training School at the University of Toronto. (Carnegie Library of Pittsburgh.)

AMERICAN VOLUNTEERS TO THE POLISH ARMY. American volunteers to the Polish army in World War I are pictured here. The three soldiers on the bottom are, from left to right, Sgt. Leon Kowalewski, Jan Kaczynski, and Sgt. Ludwik Urban. (Carnegie Library of Pittsburgh.)

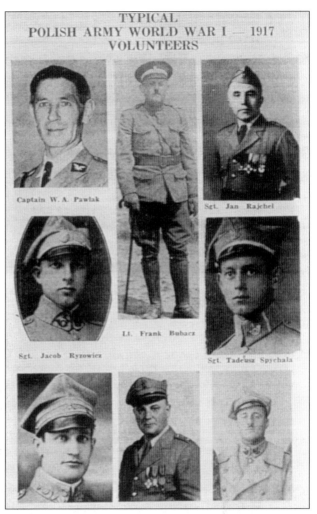

TYPICAL POLISH ARMY WORLD WAR I — 1917 VOLUNTEERS

Captain W. A. Pawlak

Sgt. Jan Rajchel

Lt. Frank Bubacz

Sgt. Jacob Ryzowicz

Sgt. Tadeusz Spychala

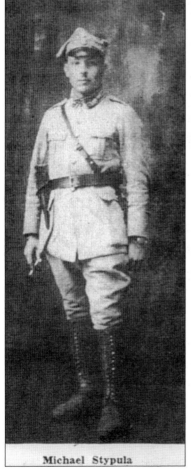

Michael Stypula

AN AMERICAN VOLUNTEER TO THE POLISH ARMY. This unidentified volunteer joined the Polish army in World War I. While there was great enthusiasm among Polish Americans to enlist for service in the Polish army, approximately five times (57,000) that number of Polish American men answered President Wilson's call for volunteers and enlisted in the US Army prior to the draft. Polish Americans made up a disproportionate contribution to the American war effort. While Polish Americans constituted only four percent of the US population in 1917–1918, they accounted for 12 percent of America's war dead. (Carnegie Library of Pittsburgh.)

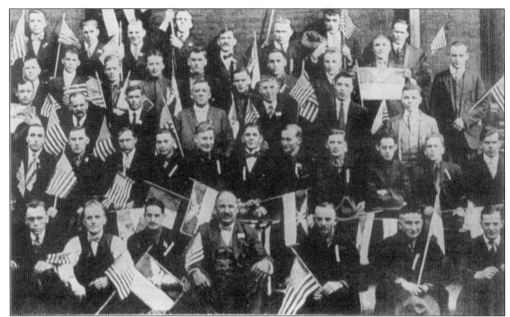

POLISH ARMY VOLUNTEERS LEAVE PITTSBURGH. Once Poland's independence was restored, only a small number of American Poles chose to remain in Poland. With World War I and the Bolshevik invasion of Poland brought to a successful conclusion, all of the servicemen desiring to return to the United States were repatriated. Seventy-eight Pittsburghers who had served for two to four years in the Polish army arrived back in Pittsburgh on May 7, 1920. The soldiers were discharged from Camp Dix, New Jersey, traveled to Pittsburgh by train, and received a hero's welcome upon arrival. The Polish army veterans maintained their own Polish War Veterans' Club on Butler Street in Lawrenceville for many years following the war. (Carnegie Library of Pittsburgh.)

PARISHIONERS BUNDLE RELIEF PACKAGES. Members of the Polish Women's Alliance of America bundle packages of clothing at the Immaculate Heart of Mary Parish on Polish Hill to send to Poland following World War II. Other Polish parishes in Pittsburgh also assisted the victims of World War II in Poland. Holy Family Church in Lawrenceville held clothing, food, and medicine drives for the relief of war victims. The pastor of Holy Family, Father Sliwinski, convinced Bishop Boyle to conduct a special diocesan collection to assist the suffering people of Poland. (Immaculate Heart of Mary Parish.)

NIKITA KRUSCHEV VISIT. In 1959, the Central Council of Polish Organizations of Pittsburgh organized a protest against Nikita Kruschev's visit to Pittsburgh. Kruschev was the premier of the Soviet Union from 1958 to 1964. (Stanley States.)

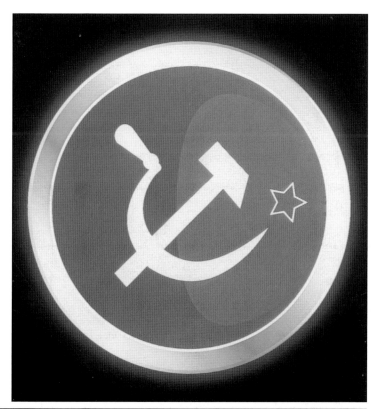

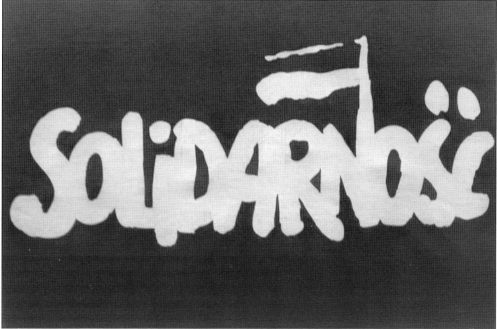

SOLIDARITY SYMBOL. Seen here is the symbol of the Solidarity movement that was instrumental in bringing down Soviet communism in Poland and throughout Europe in the late 1980s. (Stanley States.)

IMMACULATE HEART OF MARY CHURCH. A memorial mass was held at Immaculate Heart of Mary Church on Polish Hill in April 2010 to mourn the loss of Poland's president Lech Kaczynski and many of Poland's leaders in a plane crash on April 10, 2010. The plane was on its way from Warsaw to the Katyn Forest in Russia to mark the 70th anniversary of the massacre of thousands of Poles by Soviet secret police during World War II. The mass was organized by the Polish Falcons and was attended by 400 people. (Stanley States.)

Eight

STAYING IN TOUCH WITH THE OLD COUNTRY

As Poles immigrated to Pittsburgh, many of the immigrants kept alive the ties with the family who stayed behind by letter and visits. This effort to stay in touch with family in the Old Country has continued with some of the descendants of the original immigrants. This occurs now via paper mail, visits, and e-mail.

The images in this chapter illustrate the efforts of a couple of Pittsburgh Polish American families to maintain relationships with their families in Poland over the decades.

A mail correspondence has continued between the European and North American sides of the Statkiewicz/States family off and on for over 100 years. During difficult times of war, oppression, and severe economic pressures, this included sending money and goods from the United States to Poland. This sometimes involved enlisting the services of companies like Chester's travel and shipping service on Pittsburgh's South Side, which offered a variety of gift packages of items sometimes difficult to purchase in Poland, such as coffee. Sending cash was often precarious for fear that it might not reach its intended recipient. Another option was to send international bank checks. However, these checks involved a significant administrative charge and could prove inconvenient for the family in Poland to cash. It is interesting to note that letters received in Pittsburgh from the family in Poland during the early 1980s had been opened, presumably read, and then stapled shut because of the state of martial law that had been declared by Poland's prime minister Wojciech Jaruzelski in response to demonstrations and strikes directed against the communist government of Poland.

For the Statkiewicz/States family, visits back to Poland began with grandfather Joseph and grandmother Josephine traveling back and forth between New York, Poland, and Pittsburgh several times during the first decade of the 1900s, apparently trying to decide where to finally set down their permanent roots. In the late 1920s and early 1930s, their oldest son, Joseph Jr., traveled back and forth a couple of times to Poland to visit the family that remained in the Old Country. Joseph Jr. may have even taught English for a while in Poland. Mysteriously, he disappeared during one of these trips and was never heard from again. Neither the Polish side nor the American side of the family ever discovered what happened to him.

In 1978, Joseph and Josephine's grandson Stanley (the author of this book) visited Poland. One member of the Polish side of the family stated, "We have been waiting 50 years for another visit from our American family." This was an interesting trip because, at that time, Poland, like Hungary, Czechoslovakia, and a number of other now independent nations, was a satellite of the communist Soviet Union.

When the Polish family was asked what it was like to live under the Soviet system, one of them answered that as long as there was peace, they could "deal with whatever they had to deal with." The reality was that economic conditions were very difficult then. Purchasing consumer products, including food, was a challenge and required queuing-up in long lines for hours to

purchase whatever goods were available. Regular delivery of fuel for heating the home was not a given, either. In their letters, the family described spending many days without heat during Poland's cold winters.

Another visit to Poland by the author and his family in 2005 revealed much better conditions. Poland had regained its independence from Russia in 1989. The country was now operating under a basically capitalist system, and the economic situation was much brighter. However, even with much improved living conditions, cousin Wanda, who had been born in Poland in the 1920s and had lived through World War II, the Nazi occupation of the early 1940s, and the communist regime extending from the mid-1940s through the late 1980s, admitted (after a few vodkas), that the lucky side of the family had left the Old Country to come to the United States 100 years ago. Wanda believed that life had always been much tougher for the Statkiewicz family in Poland than it was for the Statkiewicz/States family in America.

JOSEPH STATKIEWICZ JR. Joseph Jr. (standing) visits his uncle Stephan Statkiewicz and his wife in 1929 in Poland. Stephan was born in 1887, and his side of the Statkiewicz family always remained in Poland. Stephan's older brother Joseph was born in 1872 and immigrated to the United States in the early 1900s. Joseph's son Joseph Jr., born in 1902, traveled back and forth between Poland and the United States in the 1920s and 1930s. (Stanley States.)

A Visit to Milanowek, Poland, 1979. This image was captured during a June Sunday afternoon in the garden of the Domachowski/Statkiewicz home in Milanowek, Poland, just outside of Warsaw. The garden contained chickens and a variety of vegetables. From left to right are Darla Minor (a friend from Oklahoma), Chester Domachowski, Bobbi Konefal, Danuta (friend of Domachowski family and interpreter), Wanda Statkiewicz Domachowska, and Stanley States. Many shots of vodka were downed during that Sunday afternoon and evening reunion before and following a chicken dinner featuring the home-raised poultry. (Minor family.)

Statkiewicz Family in Warsaw. This evening visit took place in the Stanislaw Statkiewicz apartment in Warsaw. From left to right are Chester Domachowki, Anna Statkiewicz (wife of Stanley), Wanda Statkiewicz Domachowska (Polish cousin), and Stanley Statkiewicz (Polish cousin). Wanda and Stanley had a brother, another cousin, who had been a Polish soldier and was killed during World War II. (Minor family.)

KONEFAL FAMILY IN KRAKOW. Seen here is an afternoon visit with the Konefal family in their apartment in Krakow. From left to right are Jim and Darla Minor (friends from Oklahoma), a Konefal cousin (from Poland), Stanley States, another Konefal cousin (from Poland), Bobbi Konefal (from the Pittsburgh branch of the Konefal family), and another Konefal (the mother of the other two Konefal cousins in Poland). (Minor family.)

DOMACHOWSKI/STATKIEWICZ HOME. In 2005, another visit to Poland occurred at the Domachowski/ Statkiewicz family home in Milanowek, Poland. (Stanley States.)

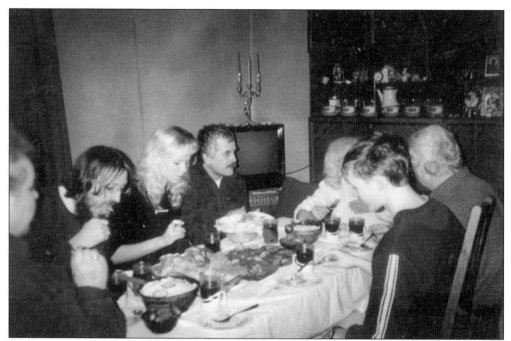

VIGILIA. Vigilia (Christmas Eve dinner) takes place at the Domachowski/Statkiewicz home in 2005. From left to right are Nina Domachowska (from Poland), Stanley Thomas States (from the United States), Nina and Andrew's daughter Iwona (from Poland), Andrew Domachowski (from Poland), Wanda Statkiewicz Domachowska (from Poland), Stanley States (from the United States), and Joseph States (from the United States). Not shown is Kathleen States, Stanley's wife, who was taking the picture. (Stanley States.)

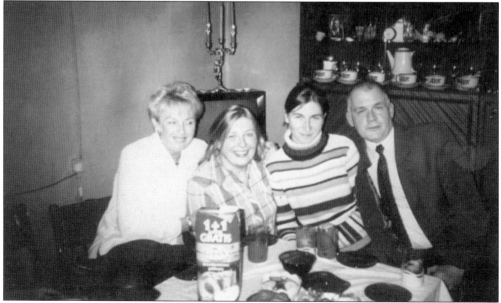

MORE VIGILIA. This is another picture taken during Vigilia at the Domachowski/Statkiewicz home. Pictured are Alec Domachowski, a Polish cousin, along with his wife and two daughters. (Stanley States.)

Cousins Trimming the Tree.
Stanley Thomas States (from
the United States) decorates the
Christmas tree with his Polish
cousin Iwona at the Domachowski/
Statkiewicz home. (Stanley States.)

Stary Miasto in Warsaw. Stary
Miasto (Old Town) in Warsaw
is pictured at Christmastime.
(Stanley States.)

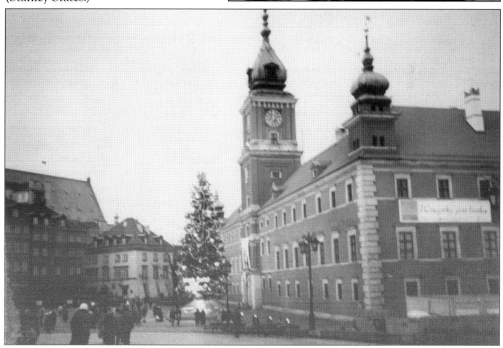

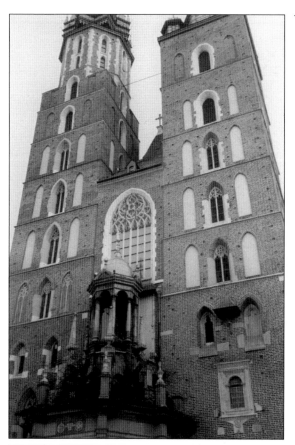

St. Mary's Basilica (Kosciol Mariacki). This church has stood in the main square of Krakow for the past 900 years. Undoubtedly, many of the family ancestors had visited this church over the centuries. (Stanley States.)

Censored Mail From Poland. The envelope shown here is one of the censored letters received from Poland in the early 1980s during the period of martial law declared in response to protests that had been staged against the communist government of Poland. (Stanley States.)

Stas States
MT. ROYAL TOWERS APTS
APT 907
7070 FORWARD AVE
PITTSBURSH PA 15217
U.S.A.

Nine

POLISH CUSTOMS
AND TRADITIONS

Over the 1,000 years since Poland first became a nation, a number of customs and traditions—many of them associated with the holidays—have been celebrated by Poles in their homeland. These customs and traditions have traveled with the Poles and their descendants as they relocated to other parts of the world such as Pittsburgh.

Wesolych Swiat is polish for "Merry Christmas." As in most majority Christian countries, especially Poland with its strong Catholic identity, Christmas is a key date in the cultural calendar. For Poles, the central event in the Christmas celebration is Vigilia, the Christmas Eve supper. The name comes from the Latin word *vigiliare*, meaning "to watch." Sheaves of wheat are placed in the four corners, or at least in the eastern corner, of the room where the dinner is held. Hay is placed under the tablecloth to remind everyone of the birth of Christ in a stable. A separate place is set at the table and left empty to remember those relatives and friends who have passed on before or for use by a stranger who might drop by.

The dinner traditionally begins with the appearance of the first star in the evening sky. A consecrated wafer (*oplatek*) is broken by the father with the mother of the house and then divided among everyone present with an exchange of warm wishes for a Merry Christmas and hopes for love, health, and prosperity in the New Year. The oplatek has a mystical meaning for Poles. At Christmas, it is sent to absent family members and friends so they can partake of it as a form of communion with their loved ones at home.

One of the most noteworthy Vigilia traditions is to invite the lonely to this meal, because no one should be left alone at Christmastime. This is in keeping with the age-old Polish proverb *Gosc w domu, Bog w domu* ("a guest in the home is God in the home").

Christmas Eve is a day of abstinence, so the dinner is meatless. The entrée is a fish, like pike, prepared in grey sauce. The soup is commonly a *barszcz* (beet soup) or mushroom soup. Other dishes are plain and include mushrooms, sauerkraut and peas, cabbage, pickled herring, pierogis, noodles, and poppy seed or nut rolls, among others. The number of dishes is traditionally 12, symbolizing the 12 apostles of Jesus. There are still a number of Pittsburgh Polish Americans who complete the Christmas Eve celebration by attending Pasterka, the Shepherds's Midnight Mass.

Christmas day itself is usually spent visiting relatives and friends. In most Polish homes, little or no cooking is done on this day.

The music of Christmas consists of old Polish Christmas carols (*koledy*). Most of the koledy were composed in the 15th century. The melodies are based on Polish dances like the *polonaise*, *mazur*, and *mazurka*. The singing of koledy in the churches is continued until the Feast of the Three Kings on January 6. On that day, songs dedicated to the Magi are sung during mass, a practice still continued in many Polish churches.

Wesolego Alleluja is Polish for "Joyous Easter." Traditionally, Poles strictly observe the 40-day penitential season of Lent, and by Easter are ready for a holiday.

Good Friday is a solemn day and customarily involves attendance at memorial services at church to commemorate the crucifixion of Christ. On Good Friday night, hard-boiled eggs are decorated with traditional designs. The old-fashioned method involved the use of boiled onion skins to dye the eggs a rich brown color.

On Easter Saturday, baskets filled with bread, ham, salt, sausage, horseradish, hard-boiled eggs, butter, and other foods are brought to church for the priest to bless. This ceremony is called Swieconka. The contents of the baskets are enjoyed at breakfast on Easter Sunday morning. This breakfast (Swiecone) is considered to be the most special breakfast of the year. The table, set with the best linen, is decorated in its center with a Paschal lamb, made of sugar, butter, or dough.

A time-honored custom associated with Easter is Pisanki, the painting of eggs. There are several methods for making Pisanki, including the use of wax flowing from a pipe or funnel, producing ornamental designs etched onto a previously colored, hollowed-out egg.

Dyngus Day is celebrated on the Monday after Easter. It is a Polish rite of spring dating back to pagan times. Unmarried women are doused with water, which symbolizes ensured fertility. In reality, Dyngus Day gives Poles an opportunity for some harmless fun after a long Lenten period of fasting and sacrifice. For years, Dyngus Day was celebrated in ethnic bars and on ethnic radio stations in American cities with large Polish populations.

As with most ethnic groups, Polish weddings were and still are rich with tradition. One popular tradition was the *oczepiny* or capping ceremony, in which the married female bridal attendants welcomed the new bride into the fold of wives. The bride's veil was ceremoniously removed and replaced with a housemaid's cap, while the women sang of the pleasures and pains of married life.

Another custom was the bridal dance, which is still celebrated at some contemporary Polish American weddings. Guests drop money into an apron held by one of the attendants, paying for the privilege of dancing with the bride, and providing the new couple with an additional small nest egg to begin their married life. At some weddings, the person making the donation is further rewarded with a shot of vodka or whiskey.

Another beautiful Polish wedding custom is the singing of the "Twelve Angel's Song" in which the guests serenade the bride while each of the angels offers a gift to the bride such as a lily, a candle, or a ring symbolizing married life.

Old-fashioned Polish weddings could involve several days of celebration. A party called the *poprawiny* was held on the second day. This name translates as "amends," or "to make it better." The celebration allowed the wedding guests the opportunity to correct their behavior in the event that they had made a spectacle of themselves on the first wedding day. It also provided an opportunity for guests to enjoy the food left over from the first day's celebration.

Szopka. *Szopka* is a Polish folk art that is displayed at Christmas. It is an ornate miniature edifice constructed from paper and foil. (Stanley States.)

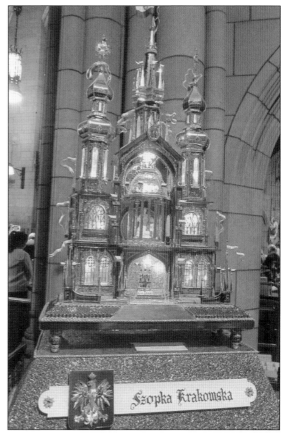

Caroling. Members of the St. Cyprian Church Choir (North Side) observe the Polish Christmas Eve tradition of caroling at people's houses during the late 1940s. Joe Baranowski is front row, center. (Konefal family.)

CAROLING, 1951. Members of the St. Cyprian Church Choir are shown singing Polish koledy at Stella Konefal's house on the North Side on Christmas Eve 1951. The two carolers in the far back are her sons: Stanley (far left) and Charlie (far right). (Konefal family.)

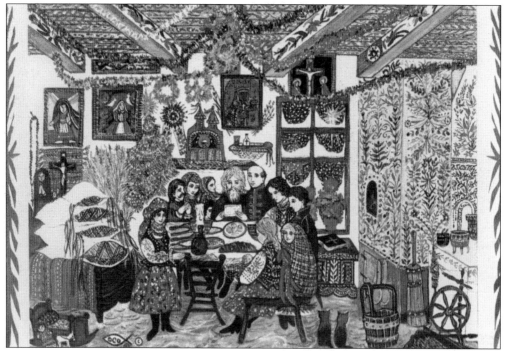

VIGILIA. This is an artist's depiction of Vigilia, the Christmas Eve supper, in the Old Country. (Stanley States.)

SANTA CLAUS. This figurine portrays the Polish version of Santa Clause. (Stanley States.)

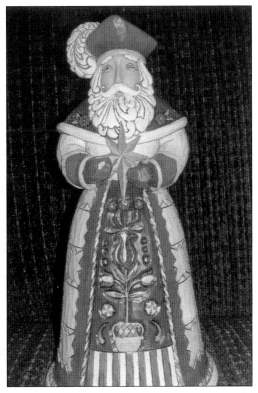

WHEAT DECORATION. A sheaf of wheat decoration is typically found at a traditional Vigilia supper. (Stanley States.)

OPWATEK AND HAY. Opwatek (blessed wafer) is shared by everyone attending Vigilia dinner along with wishes for a Merry Christmas. Hay is displayed on the Vigilia dinner table to remind those present of the birth of Christ in a manger. (Stanley States.)

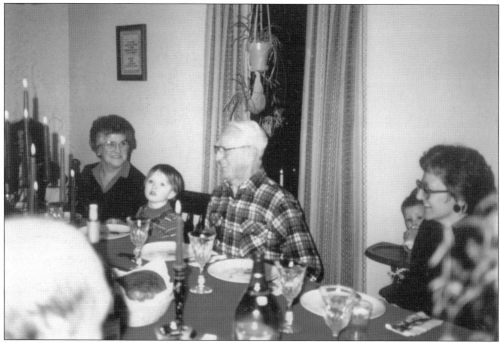

VIGILIA DINNER AT THE STATES HOUSE, 1985. From left to right are aunt Maureen States (behind candles), grandmother Betty Price, Tom States, grandfather Bill Price, Mike States (in highchair), and aunt Kathy Goliat. (Stanley States.)

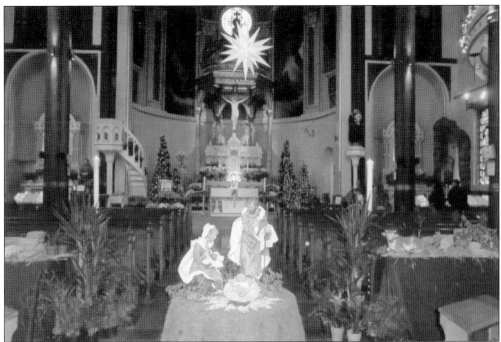

ST. STANISLAUS KOSTKA CHURCH.
The interior of St. Stanislaus
Kostka Church in the Strip
District is shown here decorated
for Christmas. (Stanley States.)

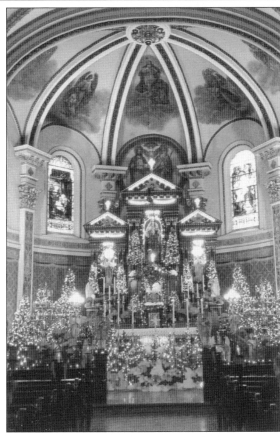

**IMMACULATE HEART OF MARY
ALTAR.** The Immaculate
Heart of Mary Church altar
on Polish Hill is decorated for
Christmas. (Stanley States.)

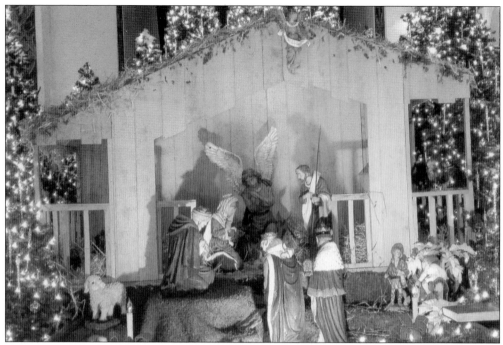

MANGER. Pictured is a manger scene in the Immaculate Heart of Mary Church. (Stanley States.)

WESOLYCH SWIAT. The Polish Christmas greeting, "Wesolych Swiat," is displayed on the front of the Immaculate Heart of Mary rectory. (Stanley States.)

140

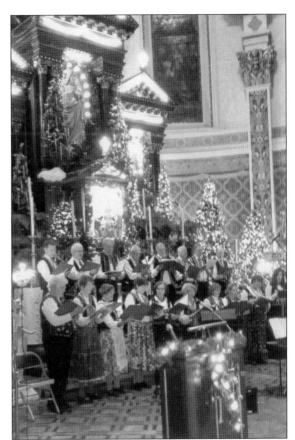

KARUZELA CHORUS. The Karuzela Chorus sings koledy, which are popular Polish Christmas carols, at the Epiphany (Feast of Three Kings) Mass in Immaculate Heart of Mary Church at the end of the Christmas season. (Both, Stanley States.)

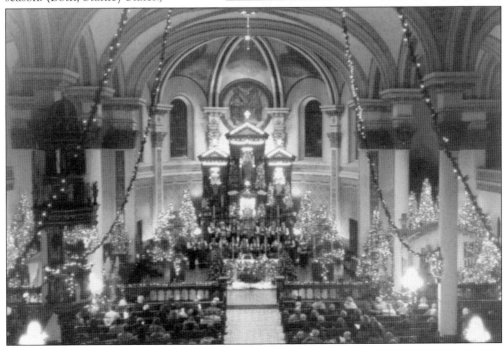

CHRIST'S TOMB. Between Good Friday and Easter morning, a replica of Christ's tomb (*Bozy Grob*) is decorated with flowers and candles. This is a 1990 photograph of Saints Cyril and Methodius Roman Catholic Church in MeKees Rocks, just outside of Pittsburgh. (Kozlowski family.)

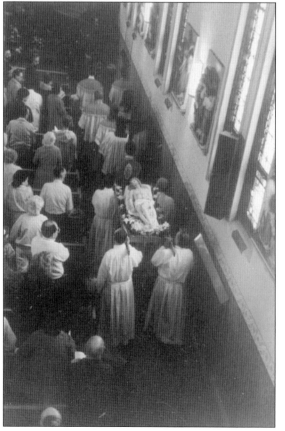

SYMBOLIC BURIAL OF CHRIST. On Good Friday afternoon, the symbolic burial of Christ is reenacted. This is a picture of that ceremony performed at St. Josephat Roman Catholic Church on the South Side in 1990. (Kozlowski family.)

BLESSING THE BASKETS. Larry Kozlowski assists Fr. Mark Thomas in the blessing of the baskets (Swieconka) on Holy Saturday in the Immaculate Heart of Mary Church on Polish Hill. Kozlowski has been very active in preserving Polish folk traditions in the Pittsburgh area for many years. (Stanley States.)

143

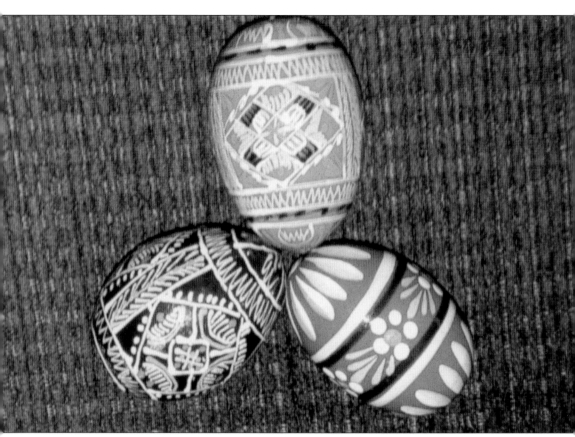

EASTER EGGS. Pictured here are decorated Easter eggs (Pisanki). (Stanley States.)

Ten

PITTSBURGH POLONIA TODAY

Polish immigrants and their children, settling in Pittsburgh and the rest of the United States, retained many of the customs and traditions of their homeland. This helped ease the transition from the Old World to the drastically different, and potentially overwhelming, New World. Polish Americans established ethnic communities, churches, fraternal organizations, and newspapers that helped them adjust as a group to America. Polish cultural life flourished, especially from the late 19th century through the first half of the 20th century. Since 1950, there has been a slow, steady decline in the number of strictly Polish organizations and Polish cultural activity. Polish Americans have successfully blended into America's culture.

However, in recent decades there has been a renewed interest among both younger and older Americans, many of mixed ethnic lineages, to rediscover their ethnic roots. There are a number of Polish groups, annual celebrations, and other activities that are currently helping Pittsburghers keep their Polish heritage alive.

The Pittsburgh neighborhood of Polish Hill has taken the lead among the traditional Pittsburgh Polish neighborhoods such as Lawrenceville, the Strip District, and South Side in showing off its Polish roots. The sign at the entrance to the neighborhood reads "*Witamy do* Polish Hill" ("Welcome to Polish Hill"). Polish Hill still has an ethnic Polish Catholic church (Immaculate Heart of Mary) that schedules masses on a monthly basis and on the holidays celebrated in Polish. The parish also holds an annual street fair in the summer, which includes a polka band and dancing, as well as displays and sales of Polish food, arts, and crafts. The neighborhood also has a civic association that includes among its goals the preservation of the Polish American ethnic flavor of this section of town. There is even a store across the street from the Polish church, Alfred's Deli and Market, that stocks foods imported from the Old Country.

Pittsburgh's main amusement park, Kennywood Park, has featured a Polish Day every summer for the past 88 years. It also offers similar days dedicated to other area ethnic groups. Polish Day includes a Polish mass and Polish singing and dancing performances as well as the crowning of Miss Polonia and the presentation of the Polonian of the Year award to an individual who has made a special effort to preserve the Polish culture locally. Also available for sale at this annual event are a variety of Polish-cooked foods as well as arts and crafts.

The Polish Cultural Council (PCC) is a very active organization in the Pittsburgh area. For years, it has sponsored a variety of events including concerts and performances by Polish artists from Poland and other parts of the world, picnics, and other social events such as the annual Ostaki party. Ostaki is the Polish equivalent of Mardi Gras and is held just before the beginning of Lent each year. The Polish Cultural Council has even scheduled workshops to assist members in tracing the meaning and history of their Polish surnames.

The Polish Room Committee at the University of Pittsburgh has sponsored an annual Polish Fest every fall in the Commons Room at the University of Pittsburgh's Cathedral of Learning.

This event includes performances by Polish and Lithuanian singers and dancers, the sale of ethnic and seasonal arts and crafts, and a full Polish kitchen.

Finally, the University of Pittsburgh Polish Studies Program, under the direction of Prof. Oscar Swan, has been very active for a number of years in offering accredited courses in Polish language, history, and other Polish studies. This program has helped to fill the void in Western Pennsylvania left by the closing of Alliance College about 20 years ago. Alliance College served as the academic center for Polish studies. The college donated its very extensive Polish library to the University of Pittsburgh upon the closing of the school.

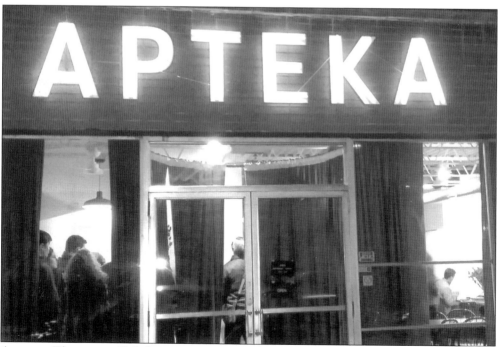

APTEKA. The newest Polish restaurant in Pittsburgh is Apteka, which has opened in the Lawrenceville/Bloomfield neighborhoods. This restaurant has a modern flair in that it features Central and Eastern European vegan cuisine. (Stanley States.)

WITAMY DO POLISH HILL. This sign, welcoming everyone to the Polish Hill neighborhood in both Polish and English, is located at one of the entrances to the neighborhood. (Stanley States.)

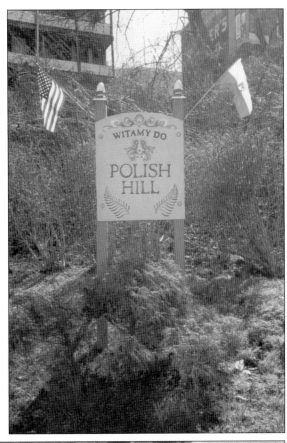

WEST PENN PARK. This sign identifies West Penn Park in the Polish Hill neighborhood. (Stanley States.)

LILI COFFEE SHOP. Some of the older Polish neighborhoods are experiencing a resurgence with an influx of younger residents and new businesses. Lili Coffee Shop is one of the new businesses that has opened in the past few years on Polish Hill and is quite popular with the local residents. (Stanley States.)

POLISH HILL CIVIC ASSOCIATION. The Polish Hill Civic Association is very proactive in keeping the old neighborhood viable while retaining its ethnic flavor. (Stanley States.)

POPE'S PLACE. Pope's Place is a tavern located across the street from the Immaculate Heart of Mary Church on Polish Hill. The name is a tribute to the late Polish pope John Paul II. (Stanley States.)

ALFRED'S DELI AND MARKET. This deli and market is located on Brereton Avenue, the main street of Polish Hill. The little store prides itself on selling a variety of Polish foods, many of which are imported from the Old Country. (Stanley States.)

85th ANNUAL POLISH AMERICAN DAY PROGRAM

2:00 PM

Accordion Music...*Dave Dombrowski*

2:30 PM

Welcome & Introduction of Honored GuestsRick Pierchalski
President, PCC

National Anthems...The Karuzela Chorus

Polonian of the Year Award..Timothy Kuzma

Crowning of Miss Polonia, Lauren Whitney...............Mary Lou Ellena

3:00 PM

Prelude of Polish Folk Songs..Karuzela Chorus
Directed by Dr. Neil Stahurski

3:30 PM

Concelebrated Mass...
Principle Celebrant with the Roman Catholic Polish-American Priests Association
Polish Hymns by the Karuzela Chorus
Wendy Blotzer, Keyboard

Karuzela Chorus Members

Janice Amend	Margie Gowaty	Joanna Raida
Jeannie Buchmann	Marilyn Hamay	Kathy Rygle
James Clark	Carl L. Josephs, Jr.	Daniel Rzewski
Rosalie Clark	Robert Kaminski	Dr. Neil Stahurski
John Csakvary	Roberta Konefal-Shaer	Sandra Stroch
Maryla Frankiewicz	Zdzislaw Lesczynski	Mary Anne Warholek
Debbie Frauenholz	Krystyna Maska	Chester Wawrzonek
Patty Frauenholz	Steve Pedersen	Monica Zanieski
Stanislawa Gil	Sally Przybycin	

Polka Dancing to the Music of
"Henny and the Versa J's"
6:00 to 9:00 P.M. at the Main Pavillion

POLISH DAY PROGRAM. Polish Day is celebrated every year at Kennywood Park, situated just outside of Pittsburgh. The day includes performances by singing and dancing groups, presentations of various awards, rides in the amusement park, and other activities, as illustrated in this program for Polish Day 2016. (Stanley States.)

POLISH DAY OUTDOOR MASS. This is a photograph of the outdoor mass celebrated at Polish Day, accompanied by the Karuzela Chorus. (Stanley States.)

POLISH DAY POLKA PARTY. Polish Day also includes dancing accompanied by a Polka band. The first Polish Day at Kennywood Park (Dzien Polski) was held on August 25, 1930. It was sponsored by the newly established (that same year) Council of Polish Organizations. The Polish Cultural Council continues the tradition.

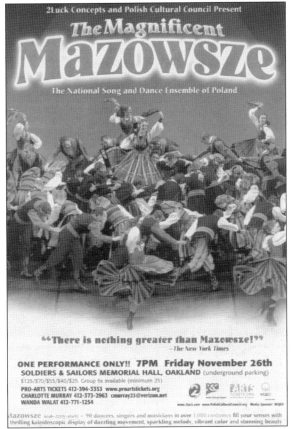

MAZOWSZE. Over the years, many singing and dancing groups from Poland have performed in Pittsburgh. This is a poster advertising a Pittsburgh performance of the world-famous Polish folk ensemble Mazowsze. (Carnegie Library of Pittsburgh.)

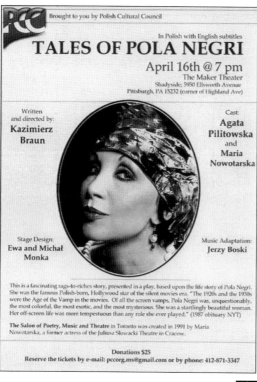

Brought to you by Polish Cultural Council

In Polish with English subtitles

TALES OF POLA NEGRI

April 16th @ 7 pm
The Maker Theater
Shadyside; 5950 Ellsworth Avenue
Pittsburgh, PA 15232 (corner of Highland Ave)

Written and directed by:
Kazimierz Braun

Cast:
Agata Pilitowska
and
Maria Nowotarska

Stage Design:
Ewa and Michał Monka

Music Adaptation:
Jerzy Boski

This is a fascinating rags-to-riches story, presented in a play, based upon the life story of Pola Negri. She was the famous Polish-born, Hollywood star of the silent movies era. "The 1920s and the 1930s were the Age of the Vamp in the movies. Of all the screen vamps, Pola Negri was, unquestionably, the most colorful, the most exotic, and the most mysterious. She was a startlingly beautiful woman. Her off-screen life was more tempestuous than any role she ever played." (1987 obituary NYT)

The Salon of Poetry, Music and Theatre in Toronto was created in 1991 by Maria Nowotarska, a former actress of the Juliusz Słowacki Theatre in Cracow.

Donations $25
Reserve the tickets by e-mail: pccorg.ms@gmail.com or by phone: 412-871-3347

Pola Negri. In April 2016, the Polish Cultural Council sponsored a performance of the play *Tales of Pola Negri* by a Canadian group of performers. Pola Negri was a well-known Polish-born Hollywood star of the silent movie era. (Both, Stanley States.)

Ewa Poblocka. In October 2016, the Polish Cultural Council sponsored a concert at the University of Pittsburgh by Polish pianist Ewa Poblocka. (Stanley States.)

FRIDAY, OCTOBER 21, 2016, 7:30 PM
FRICK FINE ARTS BUILDING AUDITORIUM
UNIVERSITY OF PITTSBURGH, OAKLAND

JOIN US FOR THE HIGHLIGHT OF THE SEASON!

Experience the one time-only appearance of Ewa Poblocka, one of the most acclaimed Polish pianists of her generation. The Prize winner of man international piano competitions, including the Tenth International Chopi Piano Competition in Warsaw, Ms. Poblocka has garnered accolades arour the world for her brilliant performances. Following her American Tour, th pianist will perform in Pittsburgh on Friday, October 21, 2016 at 7:30 PM : he Frick Fine Arts Building Auditorium University of Pittsburgh in Oaklar

IN PROGRAM: music of Mozart, Schubert and Chopin

To order your tickets, please send your check to: PCC, P.O. Box 81054,

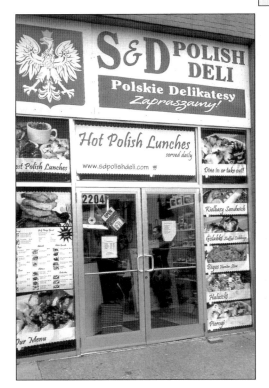

S&D Polish Deli. The S&D Polish Deli is in Pittsburgh's Strip District along with many traditional shops and restaurants frequented by people from the city, the surrounding suburbs, and tourists. The Deli sells many Polish delicacies and offers a hot Polish lunch for Strip District shoppers. (Stanley States.)

OSTATKI. Each year, on the Saturday night just before Ash Wednesday, the Polish Cultural Council sponsors the Polish version of Mardi Gras, the Ostatki, at the Pittsburgh Center for the Arts. The celebration includes dancing to a live orchestra, a Polish culinary table, and vodka tasting. Also available are the delicious pre-Lenten Polish favorite jelly-filled pastry called *panczki*. (Both, Stanley States.)

The Pittsburgh Folk Festival. This folk festival was celebrated for over 50 years. Food booths and displays of folk art were set up by a number of nationalities. A variety of amateur dancing and singing troops performed, representing many of the ethnic groups that immigrated to Pittsburgh in the past. Stanley States and his wife, Kathleen, are seen here during the 1982 folk festival. (Stanley States.)

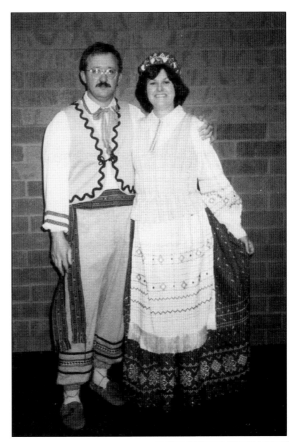

Annual Fall Picnic. The Polish Cultural Council holds an annual picnic for its members. (Stanley States.)

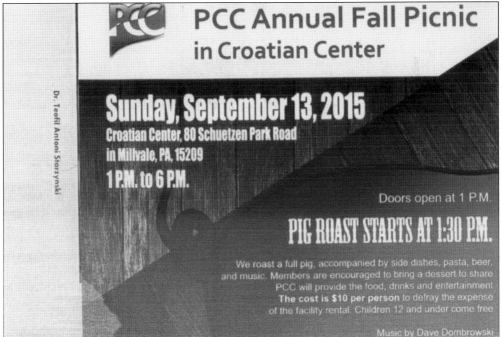

Dr. Teofil Antoni Starzynski

PCC Annual Fall Picnic
in Croatian Center

Sunday, September 13, 2015
Croatian Center, 80 Schuetzen Park Road
in Millvale, PA, 15209
1 P.M. to 6 P.M.

Doors open at 1 P.M.

PIG ROAST STARTS AT 1:30 P.M.

We roast a full pig, accompanied by side dishes, pasta, beer, and music. Members are encouraged to bring a dessert to share PCC will provide the food, drinks and entertainment **The cost is $10 per person** to defray the expense of the facility rental. Children 12 and under come free

Music by Dave Dombrowski

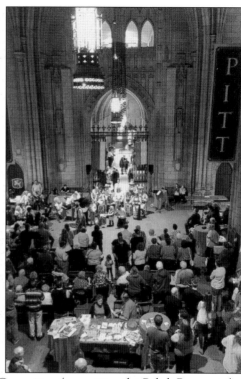

POLISHFEST '15

Sunday, November 8, 2015

Lithuania

Poland

University of Pittsburgh

Cathedral of Learning

"Celebrating 75 Years Of The Lithuanian & Polish Nationality Rooms"

History - Recipes - Program

POLISH FEST ANNOUNCEMENT. The Polish Room Committee (supporting the Polish Room at the University Of Pittsburgh) has sponsored Polish Fest for the past 32 years. (Both, Stanley States.)

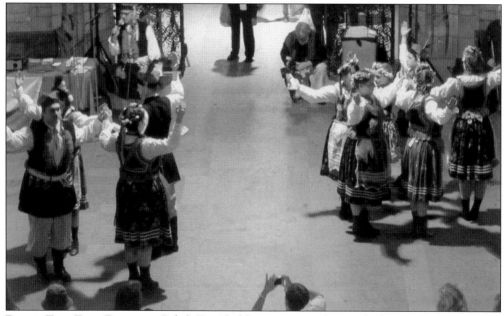

POLISH FEST FOLK DANCING. Polish Fest, held every November in the beautiful University of Pittsburgh Commons Room, has an autumn harvest theme and features folk dancing and musical entertainment. Lithuanian singing and dancing groups also participate in the celebration. (Goliat family.)

156

POLONAISE BALL. The Polish Cultural Council sponsors an annual Polonaise Ball. The event features a presentation of the debutantes and the grand polonaise—an elegant, formal Polish group dance. The evening also includes hors d'oeuvres, a buffet dinner, and dancing for all. (Stanley States.)

Frania's Polka Celebration
with Frania Yakima

WEDO Radio 810AM
Sat: 12 noon - 2 p.m.

Best in Polka Music and Polish Culture

*Celebrating 31 Years
of Broadcasting*

2008 Honoree of the Polish American
Congress of Western PA
2009 Joseph Jachimczyk Polonia Award
2011 Papal Blessing

Frania Yakima-Urbaniak
2013 Polonian of the Year

wedo 810 1918 Lincoln Highway
North Versailles, PA 15137

"ECHOES OF POLAND"
with Father Dennis A. Bogusz

Sunday 3-4 p.m.
Saturday 5-6 p.m.
Holiday Specials

Featuring the music, customs
and traditions of the Polish people
and a word of inspiration.

*Celebrating 26 Years
of Radio Broadcasting*

POLISH RADIO PROGRAMS. Pittsburgh has always maintained weekly radio programs dedicated to Polish culture and ethnic music. (Stanley States.)

BLOOMFIELD BRIDGE TAVERN. Pittsburgh prides itself on several Polish eateries. The Bloomfield Bridge Tavern (also known as the "Polish Party House") features Polish food every evening. (Stanley States.)

POLISH STUDIES ENDOWMENT. An endowment fund has been established at the University of Pittsburgh to help support the Polish Studies program at the University. Prof. Oscar Swan, a distinguished, longtime professor of Polish Studies at Pitt has championed this cause. Information on this very worthwhile program to help preserve Polish heritage is available at polishfalcons.org. (Stanley States.)

BIBLIOGRAPHY

Bodnar, John, Roger Simon, and Michael P. Weber. *Lives of Their Own: Blacks, Italians, and Poles in Pittsburgh 1900–1960*. Urbana, IL: University of Illinois Press, 1982.

Borkowski, Joseph A. *Early Polish Pioneers in City of Pittsburgh and Allegheny County*. Pittsburgh, PA: Central Council of Polish Organizations of Pittsburgh, 1948.

———. *City of Pittsburgh's Part in Formation of Polish Army—World War I*. Pittsburgh, PA: Central Council of Polish Organizations of Pittsburgh, 1956.

———. *Selected Highlights of Poland's History and of Polish American Historical Events*. Pittsburgh, PA: Polish Falcons of America, 1968.

Ellena, Louise Ellena. *Polish Hill Remembered*. Pittsburgh, PA: The After School Writers Club, 2007.

Feldman, Jacob. *The Jewish Experience in Western Pennsylvania: A History: 1755–1945*. Pittsburgh, PA. Historical Society of Western Pennsylvania, 1986.

Magda, Matthew S. *Polish Presence in Pennsylvania*. University Park, PA: The Pennsylvania Historical Association, 1992.

Misko, Louise. *A Study of Political Activities and Attitudes of Pittsburgh Poles Relative to Achieving the Independence of Poland through Preservation of Religious, Fraternal, and Cultural Institutions*. Pittsburgh, PA: seminar paper, University of Pittsburgh Department of History, 1975.

Scranton, Philip. "Father Cox, Andrew Mellon and a Huge March on Washington: Echoes." *Bloomberg View*. January 10, 2012.

Swan, Oscar E. *Kaleidoscope of Poland: A Cultural Encyclopedia*. Pittsburgh, PA: University of Pittsburgh Press, 2015.

Wudarczyk, James. *East European Ethnicity and its Effect on the Lawrenceville Community of Pittsburgh, Pennsylvania*. Pittsburgh, PA. Paper presented to the Duquesne University History Forum, 1992.

DISCOVER THOUSANDS OF LOCAL HISTORY BOOKS
FEATURING MILLIONS OF VINTAGE IMAGES

Arcadia Publishing, the leading local history publisher in the United States, is committed to making history accessible and meaningful through publishing books that celebrate and preserve the heritage of America's people and places.

Find more books like this at
www.arcadiapublishing.com

Search for your hometown history, your old stomping grounds, and even your favorite sports team.